The Hanged Man
Cézanne
and the Art of the Print

Carol Solomon Kiefer

Foreword by Jill Meredith

Mead Art Museum
Amherst College
Amherst, Massachusetts

1999

This catalogue has been produced on the occasion of the exhibition *The Hanged Man: Cézanne and the Art of the Print,* organized by the Mead Art Museum. Support for the publication was provided by the Hall and Kate Peterson Fund.

Mead Art Museum
Amherst College
Amherst, Massachusetts
January 22 through March 21, 1999

Library of Congress Cataloging-in-Publication Data

Kiefer, Carol Solomon

The hanged man: Cézanne and the art of the print/Carol Solomon Kiefer; foreword by Jill Meredith.
 p. cm.
 Includes bibliographical references.
 ISBN 0-914337-21-1
 1. Cézanne, Paul, 1839–1906—Exhibitions. I. Title
NE650.C366A4 1999
769.92—dc21
98-49432
 CIP

Designed by Su Auerbach
Edited by Douglas C. Wilson
Printed by Thames Printing Co. Inc., Norwich, Connecticut

Cover: Paul Cézanne, detail of *The Large Bathers,* fall 1896–spring 1897, lithograph, first state, 410 x 510 mm., Mead Art Museum, Amherst College (Cat. 8)

Table of Contents

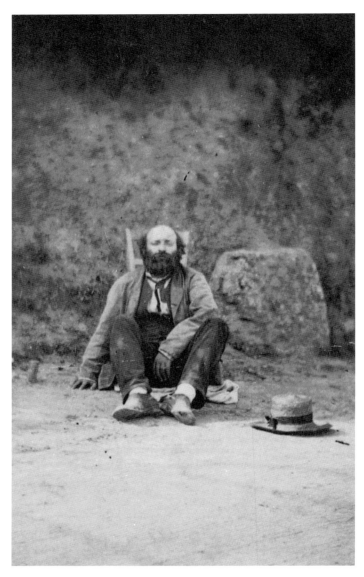

Paul Cézanne at Auvers-sur-Oise, photograph, circa 1873-74. Ashmolean Museum, Oxford

Lenders to the Exhibition

Gecht Family Collection, Chicago

Fogg Art Museum, Harvard University Art Museums

The Metropolitan Museum of Art, New York

Museum of Fine Arts, Boston

National Gallery of Canada, Ottawa

The New York Public Library

Philadelphia Museum of Art

Smith College Museum of Art

W. E. B. Du Bois Library, University of Massachusetts, Amherst

Yale University Art Gallery

Foreword

In recent years the Mead has organized exhibitions that examine the artistic processes of modern printmaking as well as the underlying cultural, even personal, circumstances of their creation. With the great strength of our print collection, and its many examples dating from the nineteenth century, it seemed fitting to feature some of the processes and personalities associated with Impressionist printmaking. Dr. Carol Solomon Kiefer, our Visiting Curator of Prints, has put her scholarly expertise into action, organizing a landmark exhibition which explores the artistic exchange and camaraderie of Paul Cézanne and his informal printmaking brotherhood. This international loan show assembles the majority of Cézanne's prints together with those of his circle, including Impressionists Camille Pissarro and Armand Guillaumin. Together they worked in the studio of amateur printmaker and collector Dr. Paul Gachet, in the village of Auvers-sur-Oise, to produce experimental prints that were innovative for their spontaneous, undisciplined appearance. For scholars, students, and general visitors alike, this project offers a rare glimpse into a fertile period of artistic collaboration that was related to the evolution of Impressionism as well as new directions in printmaking.

This ambitious project came to fruition due to the superb efforts of the author, Carol Solomon Kiefer, who has pursued this topic in depth for more than two years and brought together forty-seven works by ten artists, some well-known, some long neglected. She has marshaled her prodigious knowledge, professional contacts, and vision towards this end with great passion, patience, and good humor. Her persevering in the negotiation of loans has rendered this exhibition and catalog all the richer. I am extremely grateful for her superb ideas and their implementation, and for her friendship throughout a process that has produced an important contribution to the scholarship on Cézanne and Impressionist art as well as a vivid, intimate experience for our visitors.

This exhibition and catalog have been made possible through the generosity of our lenders, and we deeply appreciate their willingness to share these works. They enrich the project immeasurably. The Hall and Kate Peterson Fund, the Patrick and Aimee Butler Family Foundation, and the Massachusetts Cultural Council have underwritten the exhibition, catalog and associated public programs and we are grateful for their continuing support of the Mead Art Museum and its projects. We are also indebted to Frederick D. Hill (Amherst Class of 1967) of Berry-Hill Galleries, who provided additional funds for the production of the catalog.

Jill Meredith
Director, Mead Art Museum
Amherst College

Acknowledgments

Many people and many institutions were helpful to me in organizing **The Hanged Man: Cézanne and the Art of the Print.** To the individuals who gave of their time, their collections, their knowledge, and their support I am very grateful.

In particular, I would like to acknowledge the generosity of the lenders to the exhibition: Dr. and Mrs. Martin Gecht; Fogg Art Museum, Harvard University Art Museums; The Metropolitan Museum of Art, New York; Museum of Fine Arts, Boston; National Gallery of Canada; The New York Public Library; Philadelphia Museum of Art; Smith College Museum of Art; W. E. B. Du Bois Library, University of Massachusetts, Amherst; and Yale University Art Gallery.

For discussion, thoughtful suggestions, and advice in the formative stage of the project, I would like to thank Robert Herbert, Mount Holyoke College, and Barbara Stern Shapiro, Museum of Fine Arts, Boston.

Acknowledgments are also extended to the following individuals whose professional courtesy and assistance have been greatly appreciated: Betty Brace, W.E.B. Du Bois Library; Richard Brettell; Catherine Casley, Ashmolean Museum, Oxford; Marjorie Cohn, Elizabeth Mitchell, Mary Ann Tulli, Fogg Art Museum; Ersy Contogouris, McGill University; Nancy Finlay, The New York Public Library; Rita Gallagher, Innis Howe Shoemaker, Ashley West, Philadelphia Museum of Art; Michael Kiefer; Lisa Hodermarsky, Yale University Art Gallery; Suzanne Folds McCullagh, The Art Institute of Chicago; Alison McQueen, Mount Allison University; Ruth Philbrick, National Gallery of Art; Sue Welsh Reed, Museum of Fine Arts, Boston; Sabine Rewald, Susan Stein, Metropolitan Museum of Art; Aaron Sheon, University of Pittsburgh; Elizabeth Solomon; Jayne Warman; Barbara Erhlich White; and Adeline Vinçotte, Office de Tourisme d'Auvers-sur-Oise.

Special thanks to Suzannah Fabing, Ann Sievers, Alona Horn, Louise Laplante, and Michael Goodison of the Smith College Museum of Art for their continued cooperation and helpfulness.

At Amherst College, I would like to acknowledge the helpful assistance of Professor Ronald Rosbottom, Department of Romance Languages. From the Office of Public Affairs, I would like to thank Su Auerbach for her skillful design of the catalog and Douglas Wilson, who kindly edited and commented on the manuscript. I would also like to express my gratitude to Susan Lisk of Interlibrary Loans and the members of the Circulation and Reference Departments at the Robert Frost Library for facilitating my research for the exhibition.

Without the involvement of Linda Best, Registrar, and Tim Gilfillan, Preparator at the Mead Art Museum, the exhibition would not take place. I am most grateful for their many contributions. My thanks to Anne Monahan for proofreading. Other members of the Mead staff— Donna Abelli, Nicholas Dahlman, Susan Danly and Irene Farrick—offered much appreciated encouragement and help. Finally, I would like to express my sincere gratitude to Jill Meredith, Director of the Museum, for her enthusiasm, generous nature, and continued support of the project. It has been a pleasure to work with her and the staff at the Mead.

Carol Solomon Kiefer
Visiting Curator of Prints

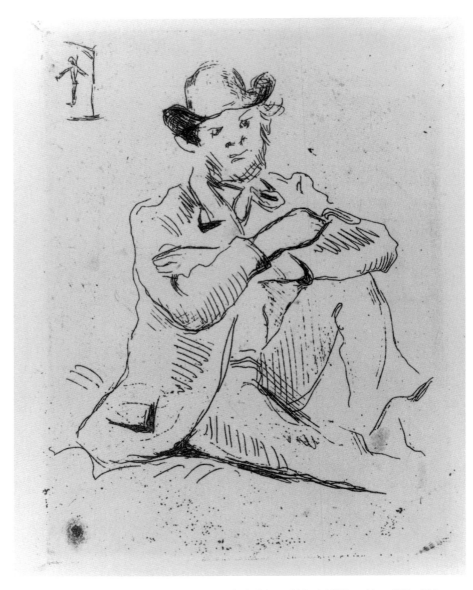

Cat. 1. Paul Cézanne, *Portrait of Guillaumin with the 'Hanged Man'*, 1873, etching, 153 x 113 mm., Mead Art Museum, Amherst College, Purchase, William K. Allison (Class of 1920) Memorial Fund. Photo: Stephen Petegorsky

Cézanne and the Art of the Print

Introduction

In 1873, Paul Cézanne executed a small etched portrait of his friend, the Impressionist artist Armand Guillaumin (Cat. 1). In the upper left hand corner of the print he included the macabre and enigmatic image of a small hanged man. What was the significance of this tiny detail? Was it a multiple visual pun—the image of a hanged man hung on the wall by a nail in the portrait (itself hung on a wall) of the artist's friend, seated at a place known as the "maison du pendu" (house of the hanged man)?[1] Or, was it an allusion to a recently completed painting by Cézanne, his most important to date, the *House of the Hanged Man, Auvers-sur-Oise* (Fig. 1), so named for its subject, this same house in Auvers?[2] Whichever of these associations is true, the image of the hanged man certainly has a complex and personal meaning that is gleaned by exploring the motif within the context of Cézanne's printmaking activity in the summer and fall of 1873.

In that context, the image of the hanged man is revealed as a symbolic signature, selected by Cézanne to identify himself as the maker of the print.[3] Claudia Rousseau has argued that it was meant to be understood not as a bleak symbol of death, but rather as a positive sign associated with the transformation his art was undergoing at the time.[4] It appeared on only one of the five etchings Cézanne executed in 1873 (Cats. 1–3, Figs. 15, 19). These works, his first and only etchings, and three lithographs (Cats. 4–12) done in the late 1890s, represent the entirety of Cézanne's printmaking activity. They are the focus of this exhibition.

The goal of the exhibition is not to recast Cézanne as one of the great printmakers of the nineteenth century. He was not. It is to examine his prints in the context of their production and to explore the nature of Cézanne's limited interest in printmaking. Although they are few in number, the prints are not insignificant. They add to our knowledge of Cézanne and bring into focus a part of Cézanne's oeuvre that invites further inquiry.

To appreciate Cézanne as a printmaker is to see him as an active participant in a truly collaborative art form, as an artist whose creativity and productivity were not always self-generated. It permits a view of Cézanne as an artist who—at one very critical period in his life—was dependent upon and nurtured by an intimate circle of friends, whose mutual support and friendship he actively pursued. This view of the artist, supported by studies of his relationship with Camille Pissarro, runs counter to the more dominant, romantic-inspired modernist conception of Cézanne as the solitary genius working alone in the isolation of the South—"the hermit of Aix."[5]

The study of Cézanne's prints reveals the close relationship he developed with Dr. Paul Gachet, the amateur painter and printmaker, who was one of the earliest supporters of Impressionism. Gachet was Vincent Van Gogh's friend and subject in the final weeks of Van Gogh's life. He was also Cézanne's first patron and a collector of Impressionist art.[6]

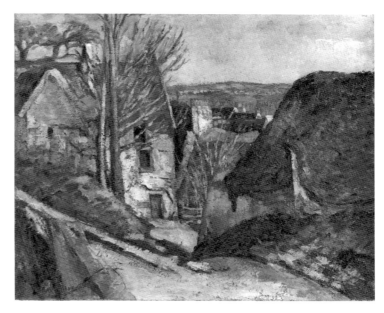

Fig. 1. Paul Cézanne, *The House of the Hanged Man, Auvers-sur-Oise*, 1873, oil painting, 550 x 660 mm. (Rewald 202), Musée d'Orsay, Paris. ©Photo RMN

The works produced by Cézanne and his small print-making circle at Auvers—Camille Pissarro, Armand Guillaumin, and Dr. Paul Gachet—represent an instance of modernist primitivism linked closely to the emergence of Impressionism. Studying them, we learn more about the little-known but significant print journal, *Paris à l'eau-forte*, to which both Guillaumin and Gachet contributed and whose editor, Richard Lesclide, was a major force in the etching revival of the second half of the nineteenth century. Our knowledge of Cézanne and his artistic universe is enlarged through the study of his life in the world of the print.

N. B. Cat. indicates works included in the exhibition. See checklist for complete catalogue information and page references for illustrations in text. All translations are by the author unless otherwise indicated.

Redrawn from Ronald Pickvance, *Van Gogh in Saint-Rémy and Auvers*, exh. cat., Metropolitan Museum of Art, New York, 1986.

Cézanne's activity as a printmaker took place during two critical periods in the artist's life, each time for very different reasons.

The five etchings of 1873 were made during a very fertile period of artistic exchange and camaraderie for Cézanne, when his art underwent a decisive transition from the dark, romantic turbulence of his early pictures to the more controlled execution of his brightly-colored Impressionist works painted directly from nature under the influence of Pissarro.

Cézanne moved to the village of Auvers-sur-Oise, about twenty miles northwest of Paris, late in 1872 and remained there until 1874. He responded warmly to the country environment and to the friendship and artistic support he received from the Impressionist painters Camille Pissarro and Armand Guillaumin, and the homeopathic doctor and amateur printmaker, Dr. Paul Gachet, in whose attic studio the four artists made prints together. At Auvers, Cézanne demonstrated a need for personal and creative interaction which was satisfied through painting and drawing excursions, informal gatherings, and the collaborative printmaking activities of his circle. It was one of the happiest, most creative, and most productive periods in Cézanne's life. In addition to the prints and numerous drawings made at Auvers, Cézanne executed around forty paintings during this period, including *The House of the Hanged Man, Auvers-sur-Oise* (Fig. 1), one of his most important works and one of the three paintings shown by Cézanne in the first Impressionist exhibition in 1874.[7]

The three late lithographs by Cézanne were done between 1896 and 1898 as commissioned works for Ambroise Vollard. He had arranged Cézanne's first one-man show in 1895 (when the artist was fifty-six). In the same year, Vollard had begun to publish albums of prints by painters. Intended for a public audience, Cézanne's lithographs were created in collaboration with Vollard and the master printer Auguste Clot. Cézanne's willingness to provide these works for Vollard suggests that, even as a mature artist, he still sought recognition and the validation of his art.

Cézanne produced hundreds of paintings, drawings (many of them after prints), and watercolors. By any measure, his prints represent a minor aspect of his oeuvre; it is not surprising, therefore, that his activity as a printmaker has been a relatively neglected subject. Cézanne's late lithographs were featured in the 1977 exhibition of his late works in New York at the Museum of Modern Art; in the 1995–96 Cézanne retrospective, held in Paris, London, and Philadelphia, the prints were ignored.[8] Only once in France, in 1972, in celebration of the one-hundredth anniversary of the creation of Cézanne's etchings, and never before in North America, has there been an exhibition devoted to the subject of Cézanne's activity as a printmaker.[9]

Because of Cézanne's very limited print production, it has been assumed that printmaking did not appeal to him. Unlike Pissarro—one of the great printmakers of the nineteenth century—Cézanne had only a limited attraction to the expressive possibilities of the print. A difficult and often solitary individual, Cézanne, it is believed, was not by nature predisposed to the collaboration, trust, and patience that printmaking requires. The mechanics of printmaking render the creative act much less direct than painting or drawing. The technical apparatus of printmaking did not lend itself to the immediacy of Cézanne's art. However, as this exhibition reminds us, Cézanne accepted the invitation to explore techniques of etching and lithography, and he participated with others in the creative process.

The prints were included in Venturi's 1936 catalogue raisonné of Cézanne's art, although only three of the etchings were known at the time.[10] The existence of the additional two works was established by Paul Gachet, whose father, Dr. Paul Gachet, first encouraged Cézanne to make prints and provided him with etching equipment and the press in his attic studio at Auvers-sur-Oise.[11] Cézanne's 1873 drawing (Fig. 2) shows him in the act of preparing an etched plate while Gachet watches over him. In conjunction with a series of publications devoted to the life and art-related activities of his father, Paul Gachet published the 1952 *Cézanne à Auvers: Cézanne graveur*, the first study devoted exclusively to Cézanne's early printmaking.[12] Jean Cherpin's 1972 *L'Oeuvre gravé de Cézanne* is the standard catalogue of Cézanne's prints. Bolstered by the contributions of Michel Melot in his various studies on the Impressionist print, Cherpin's work is particularly useful in its treatment of the etchings.[13] Because the lithographs have been more thoroughly investigated than the earlier etchings, the emphasis in this essay will be on the earlier works.

Douglas Druick's 1977 essay, "The Late Lithographs," prepared for the catalogue of the Museum of Modern Art's exhibition, *Cézanne, The Late Work*, remains the most comprehensive and authoritative treatment of this aspect of Cézanne's printmaking production; it contains a complete catalogue of the late lithographs with descriptions of their various states and editions.[14]

At the outset of his exhaustive study, Druick addresses the long-standing debate over the 'originality' of the color lithographs, which began at the end of the nineteenth century.[15] In discussing the contributions to Vollard's second album of prints in André Mellerio's 1898 book on color lithography, Mellerio associated Cézanne's *Small Bathers* color lithograph (Cats. 6, 7) with the contributions of Rodin and Sisley, each of which was, "from the standpoint of the print, less an original work than an extremely skillful chromolithographic reproduction due

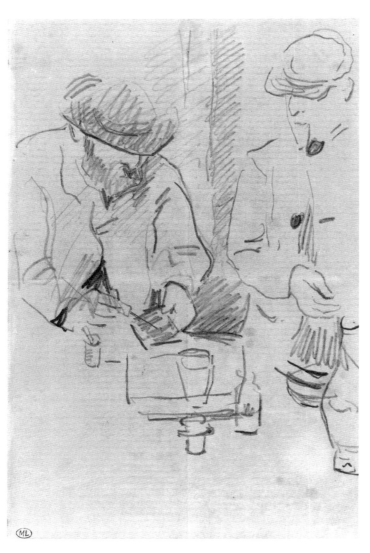

Fig. 2. Paul Cézanne, *Dr. Gachet and Cézanne: Etching*, 1873, graphite drawing, 195 x 128 mm. (Chappuis 292), Musée du Louvre, Paris, Département des Arts Graphiques, Musée d'Orsay, Paris. ©Photo RMN

to the printer Clot."[16] Druick asserts that this was not the case with Cézanne, who was much more actively involved in the production of his lithographs for the Vollard albums. Color lithography requires the preparation of a separate stone for each color in the print, and each stone must be printed with precision; therefore, artists rely heavily on the technical skills of a master printer at several stages in the making of their prints. While it is true, Druick writes, that Cézanne did not himself execute the color stones for his color lithograph, he did prepare the keystone (Cat. 4), and he provided hand-colored *maquettes* (Cat. 5) or models, to guide his printer in the preparation and printing of the color stones.[17]

An authority on prints, Atherton Curtis, asserted that Auguste Clot had informed him that Cézanne had executed the color stones as well as the keystone for his lithographs.[18] However, Druick concludes that this could not have been possible because of the high degree of technical sophistication displayed in the prints and the faithfulness of the color stones to Cézanne's color *maquettes*.[19] The fidelity of the prints to the colored models was surely the result of Cézanne's close involvement with Clot.

In addition to these essential sources and several articles devoted to specific aspects of Cézanne's printmaking activity, the general literature on the artist provides only cursory treatment of the etchings under the topic of Cézanne's period in Auvers. There, his transition to Impressionism and his relationship to Pissarro are carefully considered. Discussion of the late lithographs is subsumed under the topics of Cézanne's involvement with Vollard and his place in the revival of lithography at the end of the nineteenth century, and the theme of the bathers.[20] Important recent scholarship on Cézanne's prints includes the 1986 essay by Claudia Rousseau, which proposes a tarot association in explaining the meaning of Cézanne's puzzling, emblematic signature, and the discussion by Michel Melot in his 1996 book, *The Impressionist Print*.[21] Melot identifies Dr. Gachet's house, where their prints were made, as "one of the seedbeds of Impressionism."[22]

Despite having spent very little of his artistic career as a maker of prints, Cézanne consistently turned to this form of graphic imagery as a source of inspiration, instruction, and amusement. He made numerous drawings after prints of all kinds: original engravings; etchings;

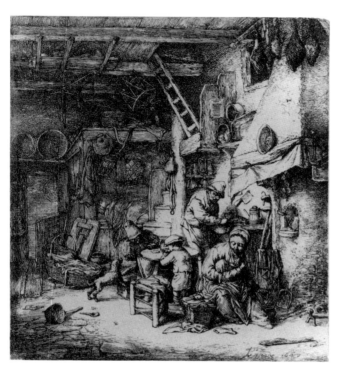

Fig. 3. Adriaen van Ostade, *The Family*, 1647, etching, 178 x 158 mm. (Bartsch 46). Photo: Stephen Petegorsky

lithographs; mediocre reproductive prints, such as the wood engravings of works of the old masters in volumes Cézanne owned of Charles Blanc's *Histoire des peintres de toutes les écoles (Ecole espanole and Ecole flamande)*; and caricatures and other popular prints found in newspapers and journals such as *Le Magasin pittoresque*.[23] Such copies constitute a major category of his drawings. At least two of Cézanne's paintings from the early 1870s were actually copies or translations of engraved fashion plates from the contemporary women's magazine *La Mode illustrée*.[24]

"More than once in Cézanne's reported conversations," writes Theodore Reff, "a book of engravings . . . is described as an object of the artist's prolonged study and intense enthusiasm."[25] Cézanne owned numerous prints—original and reproductive works by a wide variety of major and minor masters from different periods and countries.[26] Cézanne surrounded himself with these works in his last studio in Aix.[27]

Cézanne made drawn or painted copies after the works of important printmakers, most notably Marcantonio

Raimondi, Adriaen van Ostade, Francisco Goya, and Eugène Delacroix.[28] He regarded Ostade's 1647 etching *The Family* (Fig. 3) as "l'idéal des désirs."[29] While visiting the artist in 1904, Emile Bernard recalled one evening when Cézanne made a special point of showing him this

Fig. 4. Paul Cézanne, *The Family of Peasants, after Adriaen van Ostade*, 1885–90, oil painting, 460 x 380 mm. (Rewald 589), Private Collection, the Netherlands. Photo: Courtesy Rewald/Cézanne Archive, National Gallery of Art, Washington

print in a volume he kept by his bedside.[30] Appreciated for its compositional complexity and masterful treatment of light, this scene of domestic warmth and clutter has been described as "perhaps Ostade's most perfect etching."[31] In a work of the mid-to late-1880s, Cézanne freely translated the black and white print into a predominantly blue and ochre oil painting (Fig. 4). Surely Cézanne admired Ostade's ability to preserve the compositional integrity of the work beneath its profusion of detail and delicate harmonies of light and dark. In his own work, he had difficulty with this very problem. As Novotny has noted of Cézanne's works, especially his bathers, "all other elements of his art, especially the color and the pictorial structure in general, fundamentally changed and reduced the status and importance of the compositional sense."[32]

Not surprisingly, prints by or after Delacroix, one of

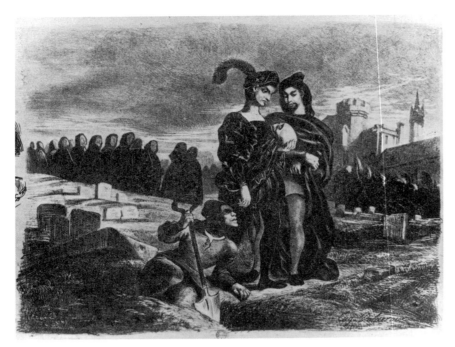

Fig. 5. Eugène Delacroix, *Hamlet Contemplating the Skull of Yorick*, 1828, lithograph, 261 x 347 mm. (Delteil 75). From Loys Delteil, *Le Peintre-graveur illustré*, vol. 3, *Ingres & Delacroix*, Paris, 1908. Photo: Stephen Petegorsky

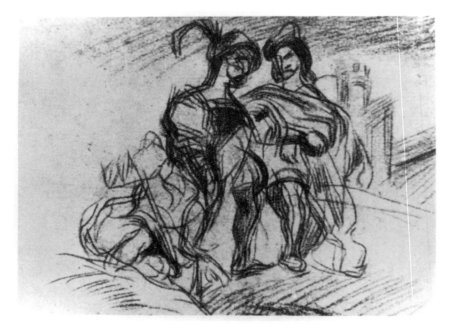

Fig. 6. Paul Cézanne, *Hamlet and Horatio, after Eugène Delacroix*, 1873, charcoal, 124 x 170 mm. (Chappuis 326), Present whereabouts unknown. Photo: Stephen Petegorsky

Cézanne's artistic heroes, outnumbered all others in the inventory of Cézanne's last studio.[33] Two of these works were original lithographs by Delacroix: *Young Tiger Playing with Its Mother* and *Lion Slaughtering a Horse*.[34]

In 1873, when Cézanne was actively making prints at Auvers, he made two drawings and a small oil on paper after Delacroix's 1828 lithograph *Hamlet Contemplating the Skull of Yorick* (Fig. 5).[35] Cézanne's preoccupation in his early works with scenes of death and violence resurfaces in his attraction to this gloomy meditation.[36] The print was in the possession of Dr. Gachet, and it was he, according to Paul Gachet, who encouraged Cézanne to make an etching after it.[37] The second drawing Cézanne produced (Fig. 6) bears out this intention, but the etching was never executed. However, the drawing was clearly made as a preliminary sketch for the etching. Its reduced size conforms to the size of the plates Cézanne was then using at Auvers, and in the definition of its forms this drawing has a more linear quality while the rendering of the other drawing is more tonal. The second drawing represents one of the rare instances in which Cézanne is actually responding to the technical qualities of the printmaker's style. In this case, according to Andersen, the effect is evident in Cézanne's use of closely spaced, parallel hatching in his drawing style of the early 1870s.[38] He concluded, however, that this trait "may depend as much on graphic models (Delacroix's lithographic technique and other modes of drawing studied by Cézanne at the time) as on an independent evolution of his style in relation to Impressionism."[39]

The print, as these few examples demonstrate, was for Cézanne a lifelong preoccupation—an endless source of amusement, appreciation, and instruction, providing him with a storehouse of imagery upon which he drew freely in response to his needs.

Etching, Dr. Gachet, and the Brotherhood at Auvers

In the summer of 1872, Paul Cézanne left Paris and moved to the country at the invitation of his friend Camille Pissarro, who had recently settled about twenty-five miles northwest of Paris in the town of Pontoise in the Oise Valley. In these nascent years of Impressionism, Pissarro was a great advocate of painting outdoors and, at Pontoise, he yearned to establish a community of artists with whom he could paint and share ideas. Throughout the 1870s, many friends came regularly.[40] Armand Guillaumin was among Pissarro's frequent visitors. He and Cézanne had become close friends since they first met in the early 1860s at the Académie Suisse. That is also where Cézanne's friendship with Pissarro had begun in 1862.

In Paris, Cézanne was living in a small, second-floor apartment at 45 rue Jussieu, opposite the Halle-aux-Vins. His mistress, Hortense Fiquet, and their son, Paul (born 4 January 1872), also lived there. Cézanne was eager for a break from the city, but he did not travel to his family's home in Aix-en-Provence; he feared that his father, who was still supporting him, would learn of his mistress and his new son. Recently rejected from the Salon, Cézanne was more irascible than usual. After a visit in February and March, Achille Emperaire reported that Cézanne had been "forsaken by everyone. He hasn't a single intelligent or affectionate friend left. Zola, Solari, etc., et. al.—all gone. It is the most astonishing scene imaginable."[41]

The situation improved when Cézanne and his family joined Pissarro in the summer of 1872. They moved into the Hôtel du Grand Cerf in the tranquil atmosphere of Saint-Ouen-l'Aumône on the Oise, just opposite Pontoise. Much needed support came from the kind and gentle Pissarro. Nine years Cézanne's elder, he was, as Cézanne would later recall, "like a father to me, someone to turn to for advice, somebody like the good Lord himself."[42]

This was the beginning of one of the most important phases in Cézanne's artistic life. It was a period during which he developed close relationships with Armand Guillaumin and Pissarro. Guillaumin was then dividing his time between Pontoise, where he would stay for intervals of a few days, and Paris, where he worked in the Department of Bridges and Highways. By September, in a letter sharing news of his circle, Pissarro praised Cézanne's progress:

> Our friend, Cézanne, raises our expectations, and I have seen and have at home a painting of remarkable vigor and power. If, as I hope, he stays some time in Auvers, where he is going to live, he will astonish quite a few artists who were too hasty in condemning him.[43]

During this period, Cézanne's circle grew to include one other member, Dr. Paul Gachet, who began to receive the threesome (Cézanne, Pissarro, and Guillaumin) at his home in the nearby village of Auvers-sur-Oise. As an artistic friend and family doctor, Gachet had been instrumental in Pissarro's decision to settle in Pontoise. Before long, he became an influential force in Cézanne's life. Gachet was Cézanne's first patron, encouraging him through the purchase of his art when outrage and criticism were the usual responses to it. Where Cézanne's printmaking is concerned, Gachet was a key figure.

The generous, outgoing doctor was an amateur painter and printmaker. As an artist, he used the pseudonym Van Ryssel, meaning in Flemish "from Lille," where he was born in 1828. From 1848 to 1858, Gachet was a medical student, first in Paris and then in Montpellier, where he completed his degree with a thesis on depression entitled *Etude sur la mélancholie*. While in the South, he met Cézanne's father, the banker, in Aix-en-Provence and was introduced to Paul, who was then nineteen.[44]

In Paris, Gachet established his medical practice in 1859, specializing in the treatment of heart ailments, nervous disorders, and the diseases of women and children. The poor were treated at his clinic without charge.

Gachet has been characterized as a free-thinking, non-conformist with radical political views, who studied positivist philosophy, anthropology, phrenology, and astrology.[45] In his medical practice, he made use of homeopathic remedies, advocated hydrotherapy, and experimented with electric shock therapy. A practitioner of preventive medicine, he promoted good health through physical exercise well before his time. Gachet was interested in cremation and tried to enlist his friends in the *Société d'autopsie mutuelle*, of which he was a founding member. He also belonged to the *Société protectrice des animaux* and, in 1888, he became the president of the *Société des Ecletiques*.

Gachet was an enthusiast of all things avant garde. He cultivated attachments in the bohemian circles of the Parisian art world throughout the middle decades of the nineteenth century. Through his close friend, the painter Amand Gautier (1825–1894), Gachet was introduced to Courbet, François Bonvin, and other artists in the Realist circle. He frequented their meeting place, the Brasserie Andler, and there met Proudhon, Duranty, and Champfleury. Daumier was his friend.

Gachet's interests in printmaking brought him in touch with important etchers such as Rodolphe Bresdin, and Charles Meryon, whom he visited at the asylum at

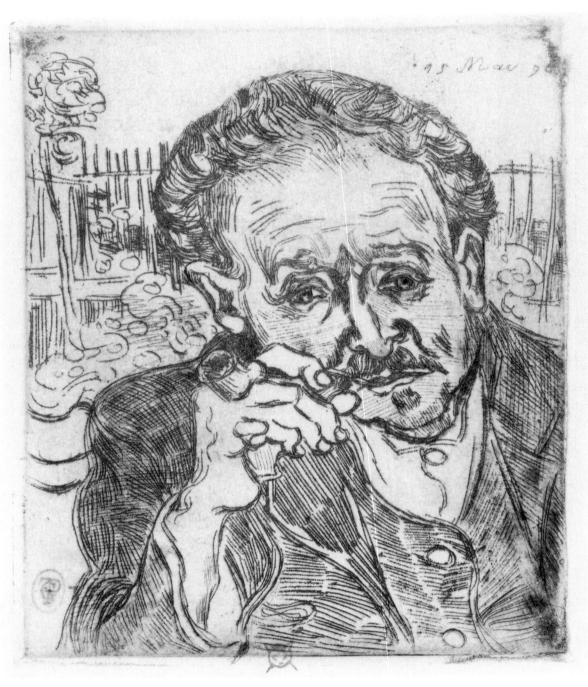

Cat. 47. Vincent van Gogh, *Man with a Pipe (Portrait of Doctor Gachet)*, 1890 etching, 182 x 152 mm., courtesy of Fogg Art Museum, Harvard University Art Museums, William M. Prichard Fund. Photo: David Mathews, ©President and Fellows of Harvard College, Harvard University

Charenton. He also knew leading figures in the etching revival, such as Charles Jacque and Félix Bracquemond and the master printers Auguste Delâtre and Alphonse Leroy, from whom he received instruction. He developed a close friendship with the writer and publisher Richard Lesclide, to whose journal, *Paris à l'eau-forte,* he contributed as an author and printmaker in the mid-1870s.

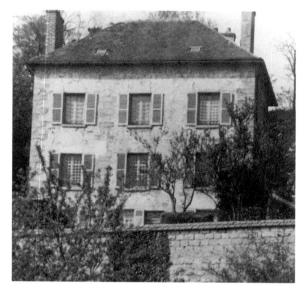

Fig. 7. Dr. Gachet's house, Auvers-sur-Oise, photograph (John Rewald, circa 1935), courtesy Sabine Rewald. Photo: Stephen Petegorsky

As a habitué of the Café Guerbois and the Nouvelles Athènes, and later as a participant at the intimate Wednesday night dinners hosted by Eugène Murer in his pastry shop on the Boulevard Voltaire, Gachet developed close friendships with many of the artists in Manet's circle. He became one of the earliest supporters and collectors of the Impressionists. Gachet had known Pissarro since the early 1860s. They first met in the studio of Amand Gautier. Gachet treated Pissarro's mother in Paris in the mid-1860s, and he provided medical care to the family for many years thereafter.

In 1872, Gachet bought a large, three-story house (Fig. 7) overlooking the Oise valley at Auvers and began dividing his time between Auvers and his practice in Paris. The house became cluttered with his many collections—antiques, paintings, and a collection of drawings and prints that eventually included more than a thousand works. In the large attic studio, reached by a ladder and a trap door, he set up a press with the necessary tools and equipment for printmaking. His collection of casts of the heads of famous criminals who had gone to the guillotine, which "so excited Cézanne's curiosity in 1873," was also housed in the studio.[46] Gachet loved animals, "nos compagnons de planète."[47] He allowed a veritable menag-

erie of pets—four dogs, twelve cats, a goat, a rooster, and a turtle—to roam freely about the house.[48] "Les Chats" was the title of an illustrated article on his favorite pets, which he wrote in 1873 for *Paris à l'eau forte.*[49]

Nicknamed "Dr. Saffron" because of his dyed yellow hair, Gachet was surely the most colorful resident in the village. In the summer, he always wore a blue overcoat and a white cap with a leather visor; he carried a green and white umbrella. Vincent van Gogh immortalized him in a few celebrated portraits, and Van Gogh's only known etching (Cat. 47) was executed in Auvers in May 1890 at the Doctor's urging.[50] The last weeks of van Gogh's life were spent in Auvers under the care of Dr. Gachet, who was recommended by Pissarro. Van Gogh described his first impressions of the doctor in a letter to his brother Theo:

> . . . rather eccentric, but his experience as a doctor must keep him balanced enough to combat the nervous trouble from which he certainly seems to be suffering at least as much as I.[51]

Close to his own house in Auvers, Gachet found a small house to which Cézanne and his family moved in late December 1872 or early January 1873. In those years, Auvers-sur-Oise was a simple village of winding country roads and picturesque stone cottages with

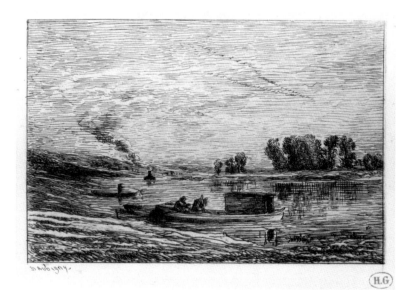

Cat. 14. Charles-François Daubigny, *The "Botin" at Conflans (The Landscapist in the Boat),* 1866, etching and drypoint, first state, 109 x 143 mm., Mead Art Museum, Amherst College, Gift of Edward C. Crossett (Class of 1905)

thatched roofs covered with moss. Its most celebrated resident was the Barbizon painter and printmaker, Charles-François Daubigny (1817–1878), who, it is reported, actually met Cézanne while he was painting in the countryside at Auvers.[52] The village was the point of

origin for the many excursions Daubigny made on the Oise and the Seine in his famous floating studio, "*le botin*," seen in his 1866 etching *The "Botin" at Conflans* (Cat. 14). The trips he made in *le botin* were the theme of his most charming and well-known series of etchings, *Voyage en Bateau,* published in 1862. Already in the 1840s and 1850s, long before he launched *le botin* and settled permanently in Auvers in 1860, Daubigny was painting in the region. He was often joined there by his friends Camille Corot and Jules Dupré.

Daumier, a friend of Gachet who was greatly admired by Cézanne and Pissarro, had been living in the nearby village of Valmondois since 1864. When Daumier died in 1878, it was Gachet who wrote his obituary for *Le Patriote de Pontoise*.[53]

Once in Auvers, Cézanne continued to visit and paint in Pontoise under Pissarro's guidance, but he preferred the quieter, more rustic atmosphere of Auvers. Cézanne worked hard and gained confidence as his style underwent a transformation. Working outdoors, directly from nature, his devotion to landscape displaced his former preoccupation with violent, imaginary themes. His dark palette gave way to the bright palette of the Impressionists. In later years, Pissarro described the nature of their working relationship, recalling that they submitted to one another's influence while retaining what mattered most, the autonomy of their unique "sensation" before nature.[54]

Cézanne made frequent use of Gachet's attic studio, especially when he was unable to work outdoors. He painted a series of still lifes and also made his etchings there. Gachet offered encouragement and artistic advice. He became the Cézanne family's doctor, and, on occasion, he intervened in Cézanne's personal life; Gachet once wrote a letter to Cézanne's father appealing for an increased allowance on Paul's behalf.[55]

Cézanne's sketchbooks from this period include several anecdotal scenes of picnics and boating parties, which record the comfort he enjoyed in this relaxed, nurturing environment. As Gowing has observed, "The socializing of the circle at Auvers was clearly at least as important to Cézanne as any emotional support that he derived from the objective method or the grandeur of humility in Pissarro's style."[56] There are also several sketched portraits of Pissarro and Dr. Gachet dating from this period. They are renderings of friendship at this special moment in Cézanne's life. Among those of Gachet, there is one sheet with a small sketch of the doctor's face next to a more finished drawing of a leisure

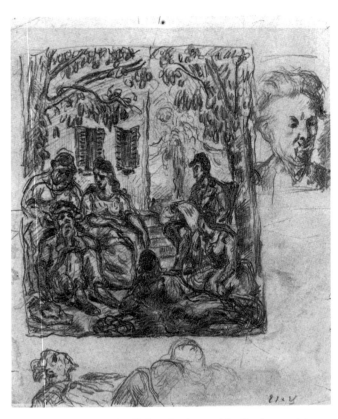

Fig. 8. Paul Cézanne, *Family in a Garden, and Studies* (upper right: small portrait of Dr. Paul Gachet), 1870-73, graphite drawing, 250 x 210 mm. (Chappuis 294), Oeffentliche Kunstsammlung Basel, Kupferstichkabinett

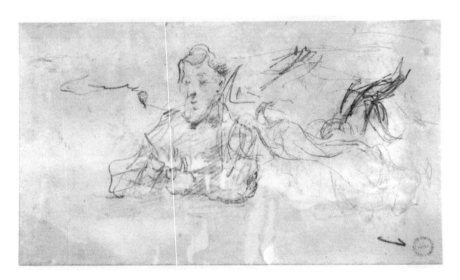

Fig. 9. Paul Cézanne, *Portrait of Dr. Gachet, and Erotic Scene*, 1872-74, graphite drawing, 103 x 168 mm. (Chappuis 291), Oeffentliche Kunstsammlung Basel, Kupferstichkabinett

Cat. 30. Camille Pissarro, *Paul Cézanne*, 1874, etching, 269 x 216 mm., courtesy of the Fogg Art Museum, Harvard University Art Museums, Francis H. Burr Fund. Photo: David Mathews, ©President and Fellows of Harvard College, Harvard University

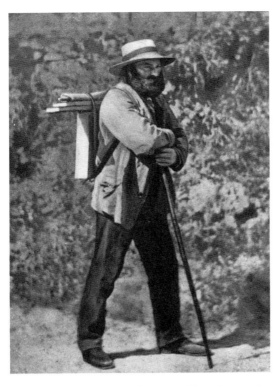

Figure 10. Paul Cézanne at Auvers-sur-Oise, photograph, circa 1874. Photo: Rewald/Cézanne Archives, National Gallery of Art, Washington

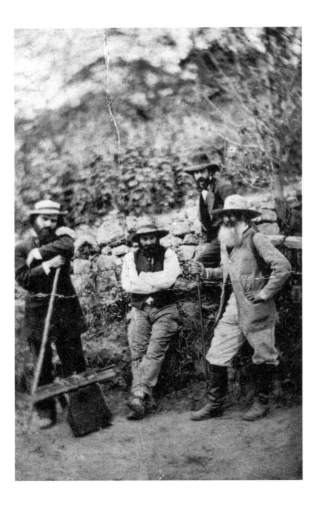

scene, set perhaps in Gachet's garden (Fig. 8). Another portrait of Dr. Gachet shows him seated at a table smoking his familiar pipe; he appears to be drawing with an etching needle on a small plate (Fig. 9).

There are at least four drawings by Cézanne, variously dated to this period or later in the decade, with Pissarro as subject.[57] During the same period, Pissarro reciprocated with some portraits of Cézanne including the etching of 1874, *Portrait of Cézanne* (Cat. 30). Forcefully rendered with a firm and direct use of the etched line, this image of a rugged Cézanne is set against a blank background. This was surely Pissarro's most accomplished print at the time of its execution, and it is one of the most captivating works in the exhibition. In 1892, this print appeared on the cover of Emile Bernard's study on Cézanne in *Les Hommes d'aujourd'hui*, and it was used again for the catalogue of the first retrospective of Cézanne's paintings organized by Ambroise Vollard in 1895.[58]

Pissarro's print of Cézanne relates very closely to an oil portrait of the artist he executed in the beginning of 1874 and kept as a personal possession for the rest of his life.[59] The painting, unlike the print, shows Cézanne without a heavy cape draped over his shoulders. In the painting, small images are tacked to the background wall of the painting. They are complex political and artistic references to both Pissarro and his sitter.[60] The cloak in the print argues in favor of a cold weather date early in 1874. About twenty impressions of the etching were printed by Pissarro in 1874, very likely on Dr. Gachet's press at Auvers. Many of these bear inscriptions to close friends. These images of Cézanne are exceptional works for Pissarro, for only rarely did he make a portrait of someone outside his immediate family. So, too, they are rather exceptional images of Cézanne, who executed his own self-portrait on several occasions but rarely sat for others. Cézanne's engagement with others at this time is further revealed in existing photographs of the artist, the greatest concentration of which are from this period (Figs.10, 11).

As other recent studies focusing on the relationship between Cézanne and Pissarro have shown, the image of Cézanne that emerges here contrasts with the more popular and dominant view of him as a solitary genius, whose artistic productivity was self-generated.[61] While this may have been true in Cézanne's later years, his creativity and productivity at Auvers and Pontoise were surely nourished by his supportive, interpersonal relationships with Pissarro, Gachet, and Guillaumin.

Fig. 11. Paul Cézanne (center) and Camille Pissarro (right) in the region of Auvers-sur-Oise, photograph, circa 1873. Photo: Rewald/Cézanne Archives, National Gallery of Art, Washington

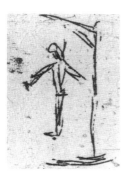

Cézanne

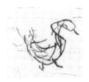

Gachet

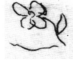

Pissarro

Guillaumin

Fig.12. Symbolic signatures of Cézanne, Gachet, Guillaumin, Pissarro

Cézanne's involvement in the collaborative art of printmaking is perhaps the clearest expression of his desire for personal and creative interaction. With enthusiastic encouragement from Gachet, and in the company of Pissarro and Guillaumin, he began to experiment with the technique of etching in the spring or summer of 1873.

Under the wing of Gachet, their undeclared leader, the artists worked together as an informal printmaking brotherhood. The dynamic of the small group was not unlike that of the many artistic fraternities that existed in the nineteenth century, most particularly the French *Barbus (the Primitifs)* from the studio of David and the German Nazarenes, who settled in Rome in the early part of the century.

In a spirit of camaraderie, the four artists exchanged prints and graphic tributes in the form of etched or drawn portraits, and they also etched copies of each other's works in various media. In a deliberately primitivizing gesture, each of the artists in the group appropriated a pictograph with which to sign his work. Gachet (van Ryssel) chose a duck; Pissarro, a small daisy; Guillaumin, a cat with an arched back; and Cézanne, the image of the hanged man (Fig 12).

Why did Cézanne choose this morbid signature? Was it a remnant of his fascination with themes of death and violence? What is its meaning?

Cézanne used this symbolic signature only once. It appeared in the upper left hand corner of his *Portrait of Guillaumin* (Cat. 1), a work believed by some to be his first print because of the awkwardness and simplicity of its execution.[62] In Venturi's description of the *Portrait of Guillaumin*, the hanged man is seen as a "drawing tacked to the wall" in the background.[63] It has been interpreted as a playful multi-layered visual pun—the hanged man hanging on the wall of the portrait of the artist's friend, which will itself be hung.[64] More often, the pictograph has been interpreted as an allusion to a major painting, completed early in 1873, of a cottage with a thatched roof in Auvers known as *"la maison du pendu."* This painting, *The House of the Hanged Man, Auvers-sur-Oise* (Fig. 2) marked Cézanne's transition to his new "Impressionist" style. Artistically, the painting represented his new identity. It was selected, along with two other paintings, for the first Impressionist exhibition, which, in the summer of 1873, was already being planned.

The subject of Cézanne's celebrated painting was treated by Dr. Gachet in one of his etchings from 1873 (Fig. 13), although the view of the house in Gachet's print is from another vantage point. In its rush of dense networks of agitated lines, Gachet's work conveys something of the haunting presence of the house's eerie namesake even though it has been determined that the association of a hanged man with this house is apocryphal.[65]

Greater understanding of Cézanne's emblem and its

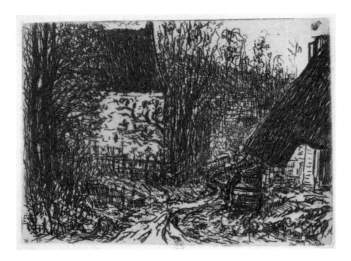

Fig. 13. Paul van Ryssel (Dr. Paul Gachet), *The House of the Hanged Man*, October 1873, etching (Gachet 9), Bibliothèque nationale, Paris. Photo: Bibliothèque nationale de France

meaning is achieved when we look to the printmaking context in which the symbolic signature originated. Adopting pictographic signatures was certainly Gachet's idea, likely inspired by the seals on Japanese prints or the emblematic identities and stylized monograms of some of the early northern printmakers. Gachet's penchant for belonging, evident in his membership in numerous societies of one sort or another, also makes it reasonable to imagine that he instigated such an activity in order to promote a sense of unity among the members of his printmaking fraternity.

Claudia Rousseau, in her intriguing essay on the meaning of Cézanne's hanged man motif, has argued that the emblematic signatures were associated with tarot cartomancy and occult interpretation in vogue in France in the 1870s and well known since the Revolution.[66] Gachet and the other members of Cézanne's group certainly knew the tarot, which, as Rousseau points out, was extremely popular in the south of France, where Cézanne grew up.[67] Indeed, the most widely used suit of tarot cards was the "Tarot de Marseilles."

Rousseau argues that "it would have been consistent with the contemporary spirit as well as with Gachet's inclinations for each of the artists' emblems to have had an occult source or symbolic meaning appropriate to each member of the group."[68] Thus, in accordance with current occult meanings, Gachet's emblem of the duck or goose symbolized a female nurturer, appropriate to his status as the group's elder and host. The cat with an arched back, which Guillaumin chose as his symbol, had associations with the occult and with eroticism; as a result of its use by Manet and Baudelaire, it also came to symbolize the struggling modern artist.[69] Pissarro's daisy, a symbol associated since the middle ages with monks, signaled "good works renewed."[70]

According to Rousseau, the Western occult identification of Cézanne's symbol of the hanged man *(le pendu)* had only one association—the twelfth card of the tarot (Fig. 14).[71] This card does not symbolize death. Rather, it is a symbol of sacrifice, transformation, and transition. For Cézanne it was an appropriate personal and artistic emblem, representing his own difficult passage in the development and renewal of his art at this time. Its use in the portrait of his close friend was also a way of acknowledging a shared artistic identification with Guillaumin. As Rousseau concludes, the etched *Portrait of Guillaumin* is "like a mirror of the artist's own positive sense of transformation as well as his awareness of the struggle and sacrifice that lay ahead. The hanged man in the upper left corner as a pictorial signature repeats this meaning symbolically."[72]

The function of Cézanne's emblematic image of the hanged man as a background detail, which conveys meaning in relation to both the subject and the artist, may have contributed to Pissarro's similarly calculated use of the images tacked to the wall in the background of his 1874 painting *Portrait of Cézanne*. The two works were produced only months apart.

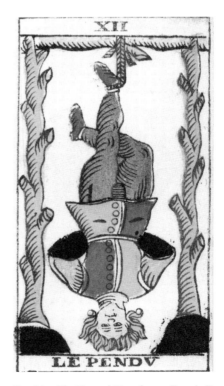

Fig. 14. *The Hanged Man*, from a French *Tarot de Marseilles*, first half of nineteenth century, Willshire Collection, British Museum. Copyright the British Museum

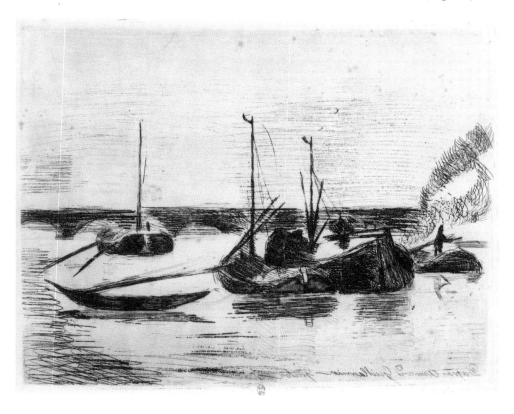

Of the five etchings that Cézanne executed at Auvers in the summer and fall of 1873, two relate directly to Guillaumin: the portrait (Cat. 1), and *Barges on the Seine at Bercy* (Fig. 15). The latter was a copy of an 1871 painting by Guillaumin in the collection of Dr. Gachet (Fig. 16). Generally identified as Cézanne's first etching at Auvers, *Barges on the Seine at Bercy* is executed in a casual manner with a traditional dependence upon a system of close parallel or cross-hatched lines, which define forms and create an atmospheric effect through contrasts of light and dark. The most conservatively rendered of Cézanne's etchings, this print is extremely rare. It exists in only one known impression, formerly in the collection of Dr. Gachet, which was given by his son in 1954 to the Bibliothèque nationale.

Modern scenes of barges and other boat traffic along the waterways in and around Paris, as in the 1873 etching *The Bercy Bridge* (Cat. 23), represent the typical subject matter of Guillaumin's paintings and prints. As a printmaker, Cézanne limited his interest in the theme to the one etched copy after Guillaumin's painting. However, a few years later, he made a painted copy of another one of Guillaumin's paintings, *The Seine at Bercy*, 1873–75.[73]

Factories, billowing smokestacks, and other signs of the encroachment of modern industry form a part of this imagery, as seen in examples of Guillaumin's etchings from 1873, such as *The Seine at Charenton* and *Seascape at Charenton* (Cats. 15, 20).

Governed by a crude linearity, these tiny prints are composed of simplified, deeply bitten, schematic forms. Guillaumin is more spontaneous and direct in his execution here than in *The Bercy Bridge* (Cat. 23), but he is capable of an even more striking and wild effect in his line as evidenced by the 1873 *Chemin des Hautes-Bruyères* (Cat. 18).

The factory and other industrial motifs were

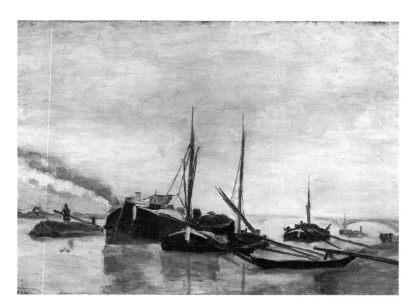

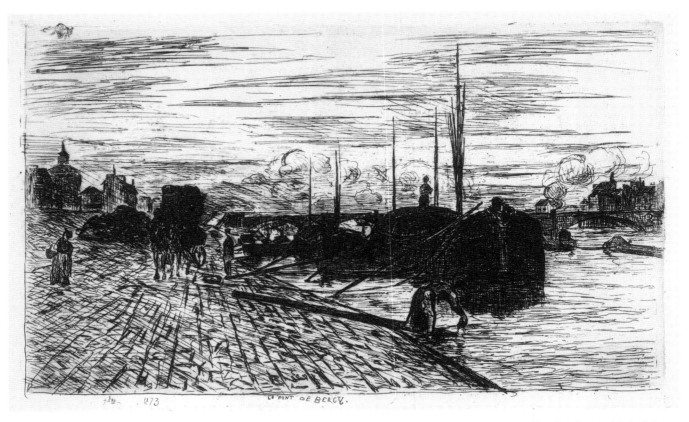

Cat. 23. Jean-Baptiste-Armand Guillaumin, *The Bercy Bridge*, 1873, etching, 170 x 267 mm., Philadelphia Museum of Art, Purchased with the John D. McIlhenny Fund. Photo: Lynn Rosenthal

Cat. 15. Jean-Baptiste-Armand Guillaumin, *The Seine at Charenton*, 1873, etching, second state, 52 x 76 mm., W. E. B. Du Bois Library, University of Massachusetts, Amherst. Photo: Stephen Petegorsky

Cat. 20. Jean-Baptiste-Armand Guillaumin, *Seascape at Charenton*, 1873, etching, second state, 47 x 77 mm., W. E. B. Du Bois Library, University of Massachusetts, Amherst. Photo: Stephen Petegorsky

Fig. 18. Charles-François Daubigny, *The Steamships*, 1861, etching, 110 x 155 mm. (Delteil 112), from *Voyage en Bateau*, 1862. Photo: Stephen Petegorsky

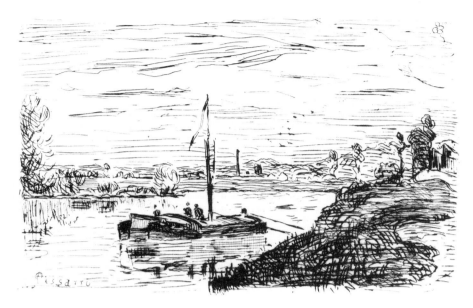

Cat. 28. Camille Pissarro, *The Oise River at Pontoise,* 1873, etching, 79 x 120 mm., S. P. Avery Collection, Miriam and Ira D. Wallach Division of Art, Prints and Photographs, The New York Public Library, Astor, Lenox and Tilden Foundation

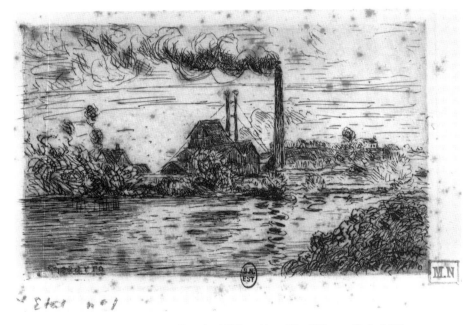

Fig. 17. Camille Pissarro, *Factory at Pontoise*, 1873, etching, 73 x 115 mm. (Delteil 10), Bibliothèque nationale, Paris. Photo: Bibliothèque nationale de France

also treated by Pissarro in a series of paintings and two small etchings done at Auvers and Pontoise in 1873.[74] The two etchings, *Oise River at Pontoise* (Cat. 28) and *Factory at Pontoise* (Fig. 17) are very close in size, but they differ in the degree to which the industrial elements intrude upon the natural landscape. *Factory at Pontoise* (Fig. 18) is a reversed copy of a painting by the same name of 1873.[75] Delteil dated both of the prints to 1874. However, because of their subject matter, intimate size, technical unrefinement, and simple, linear execution—all traits of Pissarro's *Hills at Pontoise* (Cat. 27) and other works of 1873 by members of the group at Auvers—these prints may have been done in 1873. According to Melot, two other etchings dated to 1874 by Delteil were also executed in 1873: *La Route de Rouen: Les hauteurs de l'Hautil, Pontoise,* which is an inversed copy of an 1872 painting, and *Peasant Woman Feeding a Child* (Cat. 29).[76] According to Melot, then, Pissarro executed a total of six etchings at Auvers in the summer of 1873.[77]

Returning to the subject of Pissarro's treatment of industrial imagery at this time, it has been observed that, in images such as the etchings and related paintings mentioned above, there is an ambiguity of intent in Pissarro's juxtaposition of natural and industrial elements. In trying to decipher what Guillaumin meant to convey by depicting industrial motifs in his landscapes—most notably the silhouette of a trail of smoke from a factory's chimney or from a steamship—there are clues beyond the works themselves.

One of Guillaumin's small etchings of 1873, *Bas Meudon* or *In the Tall Grass* (Cat. 21), inspired a satirical story entitled

Cat. 21. Jean-Baptiste-Armand Guillaumin, *Bas Meudon* or *In the Tall Grass*, 1873, etching, second state, 68 x 90 mm., W. E. B. Du Bois Library, University of Massachusetts, Amherst. Photo: Stephen Petegorsky.

"Promenade fantaisiste," which bemoaned the inescapability of industrialization in Paris and its outlying suburbs. This farcical tale (whose author was identified by the initials A. B.) appeared with the print in the 2 November 1873 issue of the periodical *Paris à l'eau-forte*.[78] It recounted the story of a young Parisian artist who, in need of inspiration, seeks refuge from the city and takes his beloved for a picnic in the open air and rustic solitude of the countryside, far away "to the end of the world" at Bas Meudon. After an hour's train ride, they are in the country "savoring with open nostrils the rural emanations of this delicious locale."[79] Arm in arm, as shown in the print, the lovers stroll along in the tall grass, oblivious to the ugly industrial reality that confronts them and which they so eagerly sought to escape. For certainly at Bas Meudon

> there are fully functioning factories and round chimneys of darkened bricks, very high, very high, very heavy, very heavy, which smoke, smoke, and smoke still more like the enormous cigar of a modern Gargantua. . . . But, love is blind, except for the things that deserve to be seen by those in love, and our two strollers do not care to recognize these villainous, high, gray, smoking and grim chimneys of the factory.[80]

Guillaumin's simple sketch thus provides a profound visual reminder that Parisians in the 1870s found it all but impossible to escape modern industrialization, even in the outermost suburbs of Paris.

Guillaumin and Pissarro were not the first in whose works this type of modern iconography was to appear, nor were they the first to depict scenes along the Oise, the Seine, and other waterways around Paris. Their works treating these subjects are obviously indebted to Charles-François Daubigny and Johann-Barthold Jongkind.

Because of their admiration for Daubigny, it can be assumed that his naturalistic views of the countryside and the activities on the local waterways—the Oise and the Seine—would have been of interest to Guillaumin, Pissarro, and the other members of the group at Auvers.

While the signs of industry seldom appear in Daubigny's rustic landscapes and river idylls, billowing smokestacks are a dominant motif in one of his etchings, *The Steamships* (Fig. 18), from the 1862 series *Voyage en Bateau*. A work surely known to Cézanne and his friends at Auvers, it provides a telling comparison with the works of Pissarro and Guillaumin that it anticipates by ten years.

Cézanne and his circle at Auvers would also have been interested in Jongkind's works, especially his etched views of sailboats, barges, and windmills as in the 1867 *Windmills in Holland* (Cat. 24) or his pedestrian realist subjects, such as *Demolition on the Rue des Francs-Bourgeois Saint Marcel* (Cat. 25) of April 1873. They would have appreciated the freedom and directness of his technical effects, which became even more spontaneous and expressionistic in later years, as in *Leaving the Maison Cochin, Faubourg Saint-Jacques* (Cat. 26), a work of 1878. The etchings of Jongkind are perhaps closest stylistically to those of Cézanne and his circle, possessed as they are by a similar neurosis of the line and a raw, sketch-like exuberance. As early as 1862, Baudelaire described Jongkind's etchings as ". . . curious abbreviations of his painting, sketches which will be intelligible to any amateur used to deciphering an artist's soul in his most rapid *scribbles.*"[81]

As a printmaker, Jongkind produced only twenty-two works, all etchings. Like his paintings, they often demonstrate his mastery for capturing effects of light in atmospheric settings, hence the frequent references to him as a precursor of Impressionism. Jongkind painted with Monet and had contact with many of the artists in his circle.

For Cézanne, in particular, Jongkind's prints may have provided an initial stimulus in his decision to try the technique of etching. Biographical accounts of Cézanne have overlooked the fact that he and his friend Philippe Solari lived for almost three months, from October to December 1871, at Jongkind's Parisian residence, 5 rue de Chevreuse.[82] Emile Zola visited Cézanne and Solari at Jongkind's home in December and then featured the work of Jongkind in an article of 23 January 1872 in the newspaper *La Cloche.*[83] Zola praised the truthfulness and modernity of Jongkind's views of the quays and city streets in the less picturesque neighborhoods of Paris. The immediate impact of Jongkind's art is seen in Cézanne's painting *The Wine Depot, seen from the Rue de Jussieu*, created in the winter of 1872 just after his stay with Jongkind.[84]

The unaffected directness and spontaneity of Jongkind's line endows his prints with a modern authenticity that is also found in works of the group at Auvers. Cézanne's *View in a Garden at Bicêtre* (Fig. 19) and Gachet's *A Street in Bicêtre* (Fig. 20) are the immediate

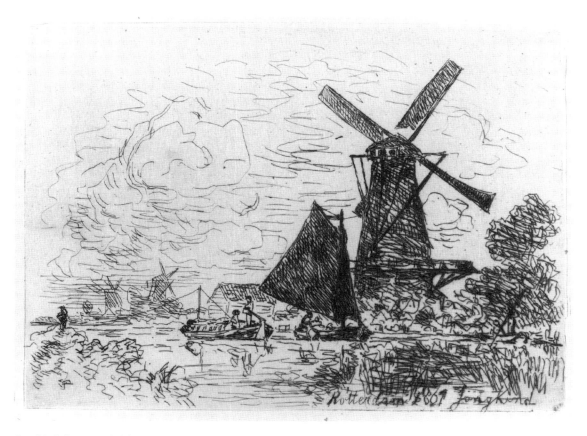

Cat. 24. Johann-Barthold Jongkind, *Windmills in Holland*, 1867, etching, second state, 147 x 195 mm., Mead Art Museum, Amherst College, Gift of Alexander C. Allison, Mary V. Allison and Peter B. Allison in memory of William K. Allison (Class of 1920) and Mrs. Allison. Photo: Stephen Petegorsky

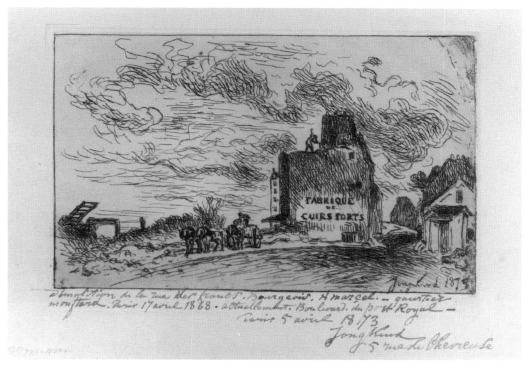

Cat. 25. Johann-Barthold Jongkind, *Demolition on the Rue des Francs-Bourgeois Saint-Marcel*, 1873, etching, second state, 160 x 243 mm., Mead Art Museum, Amherst College, Gift of Edward C. Crossett (Class of 1905). Photo: Stephen Petegorsky

Fig. 19. Paul Cézanne, *View in a Garden at Bicêtre*, etching, 1873, 105 x 127 mm. (Cherpin 3), Bibliothèque nationale, Paris. Photo: Bibliothèque nationale de France

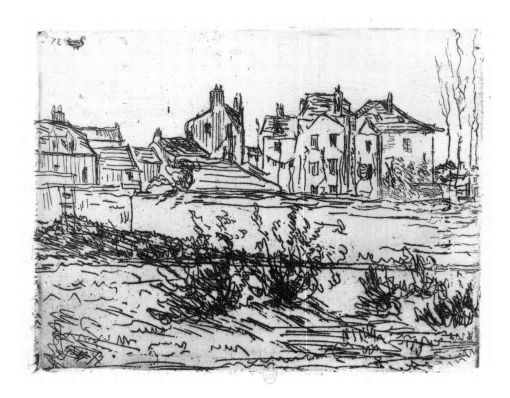

Fig. 20. Paul van Ryssel (Dr. Paul Gachet), *A Street in Bicêtre*, etching, 1873, (Gachet 3), Bibliothèque nationale, Paris. Photo: Bibliothèque nationale de France

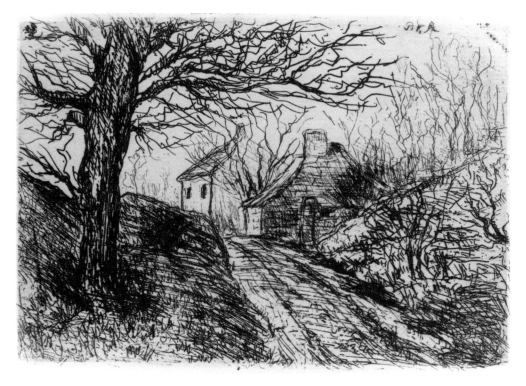

Cat. 45. Paul van Ryssel, *Murer's Walnut Tree. The Old Road to Auvers* or *Automnale*, 1874, etching, 95 x 131 mm.,W. E. B. Du Bois Library, University of Massachusetts, Amherst. Photo: Stephen Petegorsky

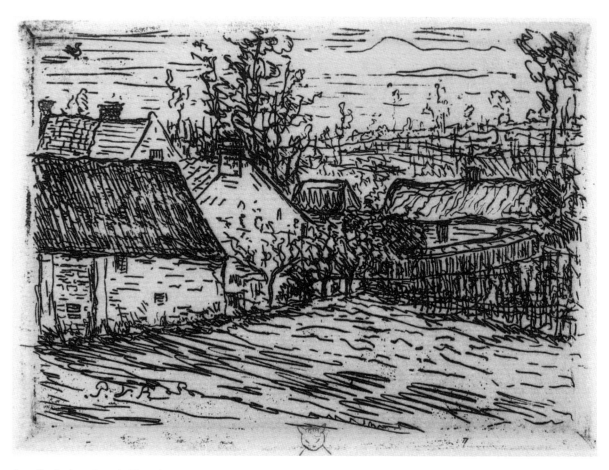

Cat. 41. Paul van Ryssel, *View of Auvers-sur-Oise*, November, 1873, etching, 119 x 156 mm., Philadelphia Museum of Art, Gift of Henry P. McIlhenny. Photo: Lynn Rosenthal

Cat. 46. Paul van Ryssel, *View of Auvers-sur-Oise at "Le Chou,"* 1874, etching, 112 x 149 mm., Philadelphia Museum of Art, Gift of Henry P. McIlhenny. Photo: Lynn Rosenthal

Cat. 39. Paul van Ryssel, *House in the Rocks (Road from Pontoise to Auvers),* August, 1873, etching, 134 x 107 mm., Philadelphia Museum of Art, Gift of Henry P. McIlhenny. Photo: Lynn Rosenthal

products of a shared sketching excursion, together representing a continuation of the same scene. These works lack sophistication, and they exhibit little concern for technical refinements; honest and direct, the unpretentiousness of their style equates with the character of their subject matter.

Unpeopled views of the local architecture, including the distinctive stone cottages with thatched roofs so appealing to Van Gogh when he arrived in Auvers, were subjects Gachet favored. With varied technical effects, he depicted views of houses and cottages along winding paths (Cat. 45, Fig. 13); clustered together in the village in *View of Auvers-sur-Oise* (1873) (Cat. 41); isolated against an atmospherically rendered hillside in *View of Auvers-sur-Oise at "le Chou"* (1874) (Cat. 46); or half-hidden by trees in the 1873 view of his own *House in the Rocks* (Cat. 39). This type of imagery abounds in the paintings Cézanne executed at Auvers. His etching, *Landscape at Auvers, Entrance to the Farm, Rue Rémy* (Cat. 3) of July 1873 was based on one of these works (Fig. 21). The print is boldly rendered with deeply etched lines that move in a variety of directions to differentiate planes and objects in space.

The practice of copying works by members of the group was again repeated in an etching by Dr. Gachet, which was based on a drawing by Cézanne, now lost, that the artist brought with him to Auvers.[85] The drawing represented a view of houses in the countryside at L'Estaque, a village near Aix-en-Provence, where Cézanne stayed during the Franco-Prussian War.

Cat. 3. Paul Cézanne, *Landscape at Auvers, Entrance to the Farm, Rue Rémy,* July, 1873, etching, 134 x 111 mm., Smith College Museum of Art, Northampton, Massachusetts, Gift of Abraham Kamberg. Photo: Stephen Petegorsky

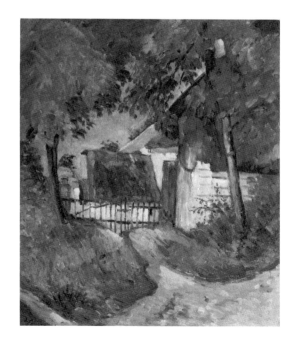

Fig. 21. Paul Cézanne, *Entrance to the Farm, Rue Rémy, Auvers-sur-Oise*, 1873, oil painting, 600 x 490 mm. (Rewald 196), Private Collection, Texas. Photo: Rewald/Cézanne Archive, National Gallery of Art, Washington

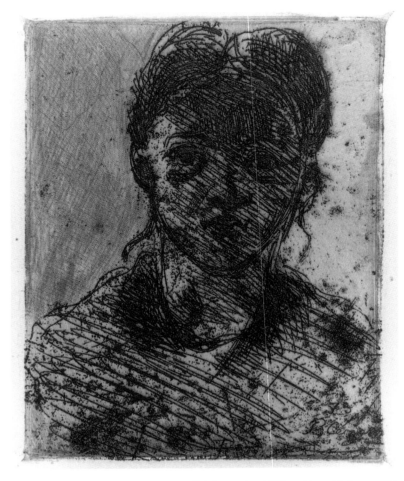

Cat. 2. Paul Cézanne, *Head of a Young Girl*, September 1873, etching, third state, 124 x 98 mm., Mead Art Museum, Amherst College, Purchase, Charles H. Morgan Fund. Photo: Stephen Petegorsky

The last of the five prints Cézanne executed at Auvers, *Head of a Young Girl* (Cat. 2), etched in September 1873, is his most technically complex etching. It exists in three states. Printed in brown or black, the dark silhouette of the girl's head is presented in *contre-jour;* the left side of the background is lightly darkened through the repetitive use of the roulette. Deeply bitten lines have been scratched into the plate and reworked in contrasting directions in a feverish effort to create volume and retrieve the features of the girl's face. The technical shortcomings of the inexperienced printmaker are evident—acid spots dot the image. But that same inexperience lends to this spontaneous work a crude vivacity and authenticity. According to Paul Gachet, the print was etched from the live model, the subject of a related drawing by Cézanne once owned by Dr. Gachet and now in Philadelphia.[86]

As Michel Melot points out, what particularly distinguishes these small prints by Cézanne is their "extraordinary violence. A combination of his unpreparedness for

the technique, the mediocre quality of his materials, and his temperament, . . . resulted in an early but undeniable return to primitivism in printmaking. . . . "[87]

In varying degrees, this characterization applies to Guillaumin, Gachet, and Pissarro, the latter of whom actually regarded himself as "a modern primitive." Undisciplined in appearance, at once innocent and deliberately crude, the prints created by Cézanne and his group at Auvers were unique in their day.

In the early 1870s, when Cézanne and his group were making prints, the etching revival, which had begun in the 1850s and intensified in the 1860s, was well under way. There was a renewed appreciation for the autograph character of the medium, for its ability, in Baudelaire's words, "to offer the crispest possible translation of the artist's personality."[88] The virtues of etching were equated with those of the artist's sketch. This aesthetic gave priority to originality and spontaneous execution, traits characterizing the prints of Cézanne and his group which were also pursued in their painting. The distinct sketchiness of a drawing could be achieved through etching with the added benefit of multiple copies.

Beginning in the mid 1870s, increasing emphasis was placed on the uniqueness and the beauty of each impression. Artists became increasingly interested in exploring ways to create various tonal effects, and they strove to create *la belle épreuve* —"the richest, most beautiful impression."[89]

This was accomplished, according to the critic Philippe Burty, when special attention was given to such factors as "the biting of the plate, the ink chosen for the printing, the actual inking of the plate, the papers used in printing."[90] One of the primary vehicles for the presentation of the print as etched drawing as well as the dissemination of the notion of *la belle épreuve* was the weekly print publication *Paris à l'eau-forte. actualité, curiosité, fantasie.* Praised by Victor Hugo as a "superb and exquisite publication," this important, though short-lived, review of the arts and entertainment, was devoted to the publication of original etchings.[91] Both Guillaumin and Dr. Gachet were among its early contributors. Cézanne and Pissarro did not seek to publish the etchings they produced at Auvers, most likely because they viewed them as private, experimental works.[92]

Circulating for less than four years, from March 1873 to December 1876, *Paris à l'eau-forte* was founded and edited by Richard Lesclide (1825–1892). He was also the director of *Le Petit Journal.* An admirer of Manet and the Impressionists, Lesclide was the publisher of Manet's illustrations for Charles Cros' *Le Fleuve* (1874) and for Mallarme's prose translations of Edgar Allen Poe's *The Raven* (1875). From 1876 to 1881 he was the secretary to Victor Hugo. Dr. Gachet considered Lesclide a close friend.

The artist Frédéric Regamey was the director of etchings and a major contributor to *Paris à l'eau-forte.* A double portrait of Regamey and Lesclide (Cat. 36), etched by Regamey for the title page of the second volume of the journal (August 1873) reflects the impor-

Cat. 36. Frédéric Regamey, *Double Portrait of Richard Lesclide and Frédéric Regamey,* 1873, etching, 56 x 73 mm. (sheet), W. E. B. Du Bois Library, University of Massachusetts, Amherst. Photo: Stephen Petegorsky

Cat. 33. Frédéric Regamey, *Paris à l'eau-forte*, 1873, etching, 92 x 101 mm., W. E. B. Du Bois Library, University of Massachusetts, Amherst. Photo: Stephen Petegorsky

Cat. 34. Frédéric Regamey, *The Free Cat*, 1873, etching, 93 x 84 mm. (image), W. E. B. Du Bois Library, University of Massachusetts, Amherst. Photo: Stephen Petegorsky

tance of his position in the administration of the periodical. Auguste Delâtre was the printer.

At first, each issue of *Paris à l'eau-forte* contained eight to ten etchings. The prints were small, often miniature-size, and glued into the text they were intended to illustrate. By the second volume (August 1873–December 1873), texts were also being written to support images obtained in advance by Lesclide or Regamey. In the second year, the size of the etchings increased and single prints such as Gachet's *Murer's Walnut Tree, The Old Road to Auvers* (Cat. 45) were featured as full inserted pages.[93] Gachet's print appeared with the title *Automnale* in October 1874, accompanied on the adjacent page by a poem of the same title.

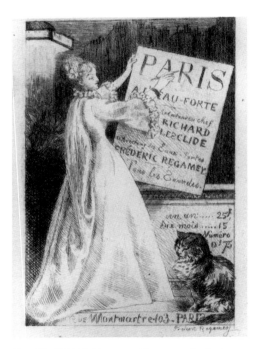

Cat. 35. Frédéric Regamey, *First poster for Paris à l'eau-forte,* 1873, etching, 88 x 62 mm., W. E. B. Du Bois Library, University of Massachusetts, Amherst. Photo: Stephen Petegorsky

The first etching to appear in the first (advance) issue was an emblematic print by Regamey consisting of an assortment of allegorical medallions featuring the various subjects treated in the review: history, sports, theater, poetry, biography, balls, concerts, museums, salons, and more (Cat. 33). Reduced etched versions of the first two posters for the review, also by Regamey, were illustrated and explained in one of the early issues (Cat. 35). Each of them includes the image of a cat, the ubiquitous mascot of *Paris à l'eau-forte*, to which an entire issue was devoted. "*Les Chats*" (no. 7, 11 May 1873) was illustrated with nine etchings by Regamey; the author of its text was none other than Dr. Gachet.[94]

In marked contrast to the contemporary works of

Cat. 42. Paul van Ryssel, *Notre Dame de Paris*, 1873, etching, 72 x 112 mm., W. E. B.
Du Bois Library, University of Massachusetts, Amherst. Photo: Stephen Petegorsky

Cat. 43. Paul van Ryssel, *Riverbank at Guernsey*, 1873, etching, 37 x 100 mm.,
W. E. B. Du Bois Library, University of Massachusetts, Amherst. Photo: Stephen
Petegorsky

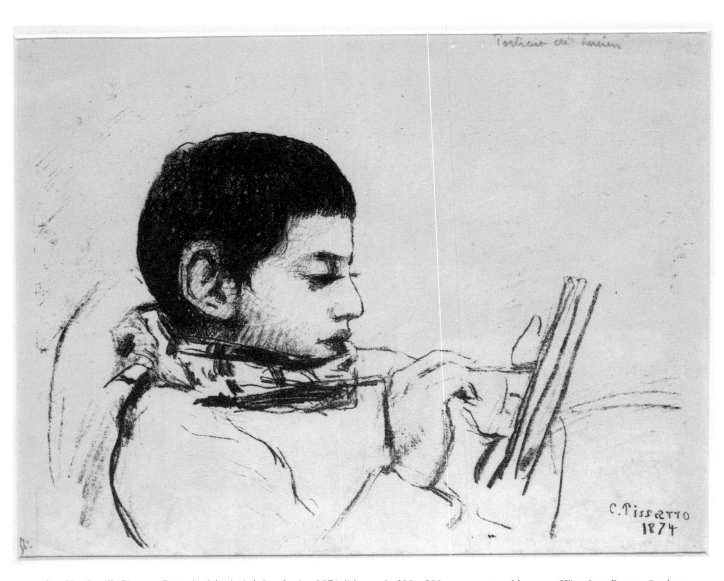

Cat. 31. Camille Pissarro, *Portrait of the Artist's Son, Lucien,* 1874, lithograph, 210 x 280 mm., courtesy Museum of Fine Arts, Boston, Stephen Bullard Memorial Fund, 1972

Cézanne and his group is the refinement and sophisticated handling of Regamey's delightful etching *The Free Cat* (Cat. 34). Appearing in the fourth issue (20 April 1873) with a sonnet of the same title, it was one of numerous isolated tributes to this animal, revered for its "grace and independence," in the early issues of *Paris à l'eau-forte*.

In its first year alone, three hundred etchings, many by Regamey, were published in *Paris à l'eau-forte*. Before ending circulation, it included among its contributing artists Félix Buhot, Jules Breton, Jean-Louis Forain, Henri Guérard, Félicien Rops, and Henri Somm.

Eleven etchings by Guillaumin were published between August and November 1873 in the second volume of the first year of *Paris à l'eau-forte*.[95] In the epilogue to the first volume, Lesclide previewed some of the highlights of the next volume. Without mentioning Guillaumin by name, he singled out his prints depicting scenes of "la Banlieue de Paris" (Cats. 15–22).[96] Lesclide praised them for having a "great ruggedness and lively originality," as in *Chemin des Hautes-Bruyères* (Cat. 18).[97] At the same time, he cited other works to come, including some "very fine and graceful studies," demonstrating Lesclide's desire to promote more than one type of etching style in his periodical.[98] Early in May 1874, another one of Guillaumin's prints, a view of Bicêtre and the surrounding waste area, appeared in *Paris à l'eau-forte* with a brief introduction by Lesclide.[99] Before commenting on Guillaumin's ability to capture the sinister desolation of this region, he noted what a "sensation" his paintings had made at the exposition of the boulevard Capucines (the first Impressionist exhibition, which had opened in April).[100] Lesclide was a supporter of the Impressionists and a positive review of the exhibition had appeared in *Paris à l'eau-forte*.[101]

In December 1873, a series of small etchings by Gachet—including the atmospheric *Notre Dame de Paris* (Cat. 42) and the delicate *Riverbank at Guernsey* (Cat. 43)—illustrated the essay by Richard Lesclide entitled "Une Soirée chez Victor Hugo" (no. 40, 28 December 1873).[102] Reflecting Gachet's pursuit of *la belle épreuve*, these works display a greater interest in tonal effects, and they have a linear refinement that contrasts with his nearly contemporary etched views of houses at Auvers (Cats. 39, 41, 45, 46). Gachet's exploration of new and varied tonal effects would continue for several years. Already in 1874, he was experimenting with the use of aquatint; in 1875 he created at least two monotypes.[103] The corpus of Gachet's printmaking production, compiled by his son, Paul Gachet, consists of one hundred works, the last from 1905, just four years before the artist's death at the age of eighty-one.

After leaving Auvers in 1874, Cézanne, like Guillaumin, never returned to the medium of etching. But for Pissarro, who had already made some etchings in the 1860s, the attraction to etching led to another period of close collaboration, beginning in 1879, with Edgar Degas. Together, at least until 1882, they explored a wide range of traditional and experimental effects made possible through the use of etching. Evidence of Pissarro's technical diversity and his ability to create a new and different work with each successive state of an etching is provided by *Peasant Woman Feeding a Child* (Cat. 29), after Jean-François Millet. Originally conceived in 1873 as a purely linear image, this small etching was transformed in 1889 into a completely tonal image through the addition of aquatint and some reworking of the plate.

Pissarro is known as one of the most innovative painter-printmakers of the nineteenth century, and he was surely one of the most productive, creating more than two hundred works in his lifetime.

In 1874, Pissarro began to experiment with the recently improved technique of transfer lithography, choosing as his first subject a portrait of his eldest son, Lucien (Cat. 31). In this technique, later used by Cézanne, the artist draws on a specially coated paper which, when moistened and passed through a press, is transferred to the lithographic stone. One of the great advantages of this process is that the final print retains the orientation of the original drawing.

In *A Street at Les Pâtis, near Pontoise* (Cat. 32), another transfer lithograph of 1874, Pissarro focused on the central figures in one of his most important paintings of this period, *The Railway Crossing at Les Pâtis, near Pontoise*, 1873–74, to form the composition of his print.[104] After executing twelve lithographs in 1874, he did not return to this technique until the 1880s. From then on, his artistic repertoire always included prints.

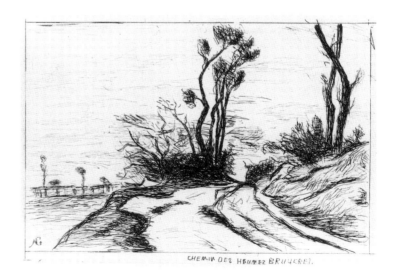

Cat. 18. Jean-Baptiste-Armand Guillaumin, *Chemin des Hautes-Bruyères*, 1873, etching, second state, 76 x 107 mm., W. E. B. Du Bois Library, University of Massachusetts, Amherst. Photo: Stephen Petegorsky

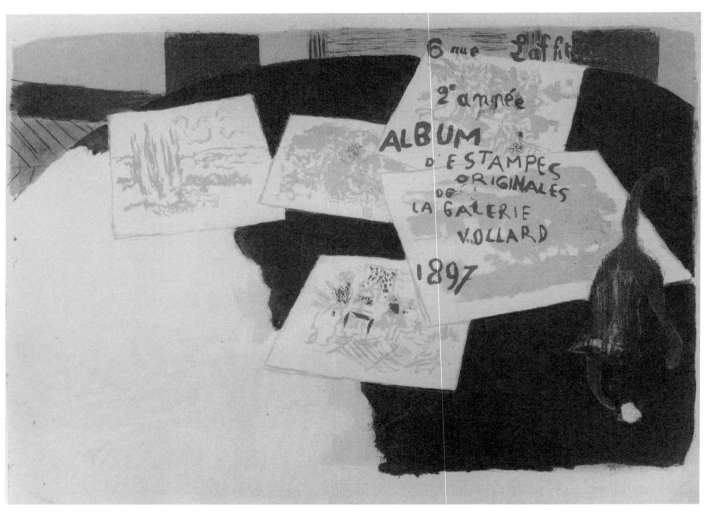

Cat. 13. Pierre Bonnard, Portfolio cover for *L'Album d'estampes originales de la Galerie Vollard,* 1897, lithograph in brown, yellow, green, orange, and beige, 583 x 865 mm. (image), Smith College Museum of Art, Northampton, Massachusetts, Gift of Selma Irving (Class of 1927), 1984. Photo: Stephen Petegorsky

A break of a quarter of a century separated Cézanne's first and only experiments in etching and his return to printmaking in 1896. Through the urging of his enterprising young dealer, Ambroise Vollard (1867–1939), Cézanne became involved in the technique of lithography and produced three prints. In the creation of these works— a self-portrait (Cat. 12) and two color lithographs on the theme of male bathers (Cats. 4–11)—Cézanne collaborated closely with his publisher, Vollard, and with the highly skilled Auguste Clot, known to be the foremost printer of his day.

This second period of Cézanne's activity as a printmaker is set against the backdrop of another printmaking revival. In the 1890s, the technique of lithography as an artist's medium experienced a renaissance, the focus of which was the color print.[105] At the start of the decade, this revitalization was initiated by the spectacular lithographic prints and posters of Henri de Toulouse-Lautrec, perhaps the most celebrated of all practitioners of the technique of color lithography. Also contributing to the renewal of interest in the medium was the publication, between 1893 and 1895, of André Marty's *L'Estampe originale*, a periodical devoted to original prints by contemporary artists.

Marty's success inspired the entrepreneurial Vollard to embark on his own very similar publishing ventures. Having enlisted several painters to produce prints for him, Vollard published a series of print portfolios, the first of which—a set of twelve color lithographs by Pierre Bonnard—appeared in 1895.[106] He then published two successive print albums containing the works of more *peintres-graveurs*. *L'Album des peintres-graveurs* appeared in 1896 and *L'Album d'estampes originales de la Galerie Vollard* in 1897. Thirty-two prints by thirty-one artists— including Denis, Redon, Rodin, Toulouse-Lautrec, Vuillard, and Whistler—graced the pages of the 1897 album. The title/cover page was executed by Bonnard (Cat. 13). Armand Guillaumin was represented by one print, and the album contained Cézanne's only published lithograph, *The Small Bathers* (Cat. 6), which was given the title *Le Bain*. Cézanne's two other prints were to have appeared in Vollard's 1898 album, but the financial failure of the earlier portfolios precipitated Vollard's decision to abort this project.

The most significant event in Vollard's historic association with Cézanne was the 1895 exhibition of Cézanne's paintings, which Vollard organized on the recommendation of Pissarro and Renoir. This was the first retrospective of Cézanne's art, and it was a major turning point in the lives of both artist and dealer. For the first time since the

third Impressionist exhibition in 1877, the seldom seen works of the enigmatic and controversial Cézanne were brought to the public's attention. After seeing the show, one critic pronounced in *Le Figaro*,

> . . . Today it has suddenly been discovered that Zola's friend, the mysterious man from Provence, the painter simultaneously incomplete and inventive, sly and uncivilized, is a great man.[107]

Vollard, twenty-eight years of age at the time of this exhibition, was a relative newcomer to the profession of art dealing. Having failed at the study of law, the young art enthusiast, born on the French island of La Réunion in

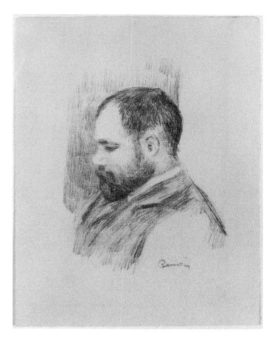

Cat. 38. Pierre-Auguste Renoir, *Ambroise Vollard*, 1904, lithograph, 247 x 178 mm. (image), Smith College Museum of Art, Northampton, Massachusetts, Gift of Selma Erving (Class of 1927), 1975

the Indian Ocean, had been buying inexpensive art works, including five Cézanne paintings in 1892. Vollard decided to make art dealing his profession and, in 1894, opened a shop at 6 rue Laffitte, the so-called *"rue des tableaux."*[108] Before long, his small gallery was the meeting place of avant garde artists. Although Cézanne was seldom seen there, his friends Pissarro, Renoir, Degas, and others were frequent visitors. Renoir's 1904 lithograph of *Ambroise Vollard* (Cat. 38) is one of several portraits of the dealer by the artists he supported.[109]

Eager to capitalize on his success, Vollard included eight of Cézanne's works in the exhibition he organized in

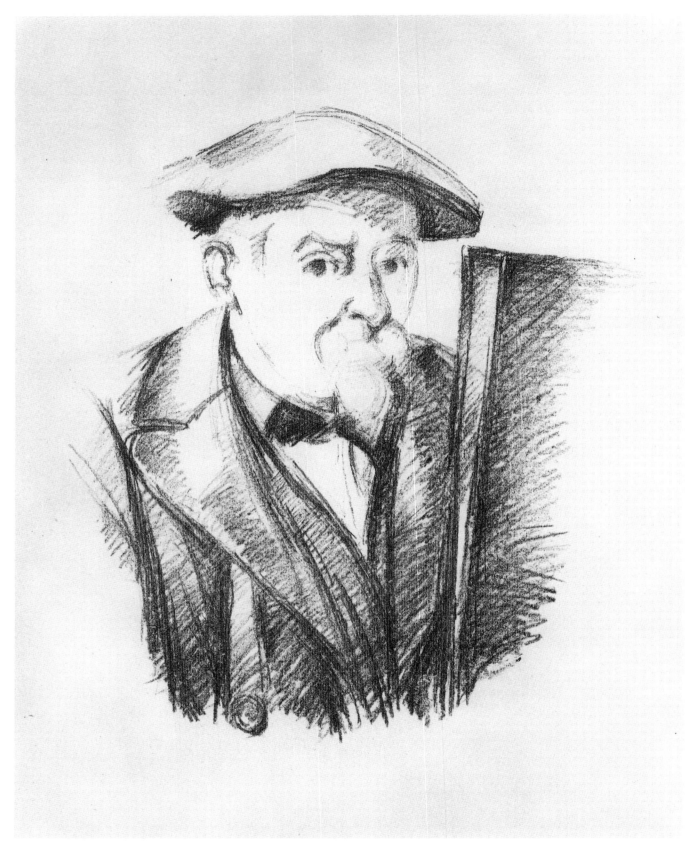

Cat. 12. Paul Cézanne, *Portrait of Cézanne*, 1896–1897, lithograph in black, only state, 324 x 279 mm. (image), Smith College Museum of Art, Northampton, Massachusetts, Gift of Selma Erving (Class of 1927), 1972

the summer of 1896 in conjunction with the publication of his first album of artists' prints, *L'Album des peintres-graveurs*. According to Druick, this exhibition was a showcase for the works of artists whose prints he had published or was planning to publish.[110]

At that time, Cézanne's only prints were the Auvers etchings. One of them, identified simply as *Paysage* (most likely *Landscape at Auvers, Entrance to the Farm, Rue Rémy*, Cat 3), was included in the Vollard exhibition along with six watercolors and one drawing.[111] Soon after the exhibition, most likely when Cézanne returned to Paris in the fall of 1896, Vollard persuaded him to produce a few lithographs. We know from Vollard's writings and Cézanne's existing letters to him that Cézanne had developed a trusting, friendly relationship with his dealer; he was willing to comply with Vollard's request in spite of his lack of experience with the medium.[112]

The issue of the chronology of the three prints Cézanne produced for Vollard has been examined closely by Druick.[113] Prior to his studies, it had been assumed that *The Small Bathers* was the earliest of the three prints because of its appearance in the 1897 album. Druick

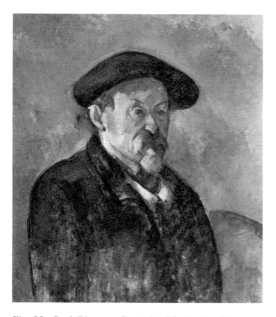

Fig. 22. Paul Cézanne, *Portrait of the Artist with a Beret*, 1898–1900, oil painting, 633 x 508 mm. (Rewald 834), Museum of Fine Arts, Boston, Charles H. Bayley Picture and Painting Fund and Partial Gift of Elizabeth Paine Metcalf. Photo: courtesy Museum of Fine Arts, Boston

proposed an alternate chronology on the basis of stylistic and technical comparisons of the black and white keystones, differences between the *maquettes* and the color prints, and evidence relating to Vollard's role in the selection of the subject matter and the choice of technique. Druick argued that because the original drawings for *The Large Bathers* (Cat. 8) and the *Portrait of Cézanne*

(Cat. 12) were executed on transfer paper rather than directly on the stone as was the case for the design of *The Small Bathers* keystone (Cat. 4), they were probably done before *The Small Bathers*. He posited that the artist unfamiliar with lithography would be more inclined to work with the transfer technique, especially if his original design was based on an existing model.[114] In such cases, the use of transfer paper would avoid the problem of having to work in reverse as when drawing the image directly on the stone in order to preserve the orientation of the original model.

The *Portrait of Cézanne* (Cat. 12) is closely related to the painting *Self-Portrait with a Beret* (Fig. 22), dated by Rewald to 1898–1900. *The Large Bathers* (Cat. 8) was

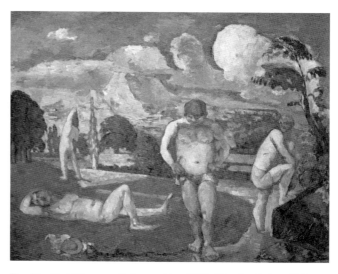

Fig. 23. Paul Cézanne, *Bathers at Rest*, 1876–77, oil painting, 790 x 970 mm. (Rewald 261), The Barnes Foundation, Merion, PA, BF #906 Gallery VIII © Reproduced with the Permission of The Barnes Foundation™ All Rights Reserved.

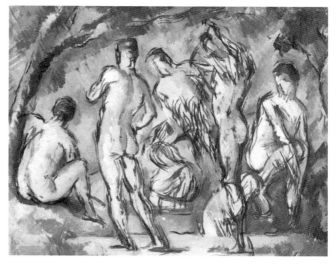

Fig. 24. Paul Cézanne, *Seven Bathers*, circa 1900, oil painting, 370 x 450 mm. (Rewald 860), Fondation Beyeler, Riehen/Basel.

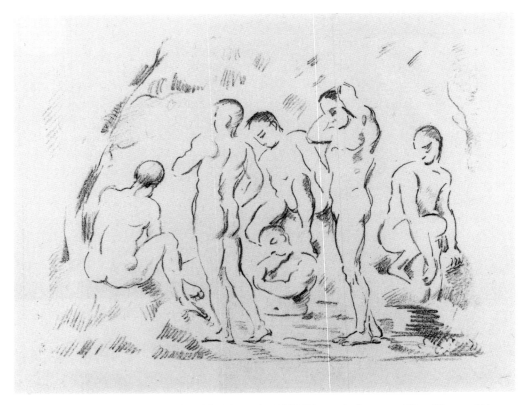

Cat. 4. Paul Cézanne, *The Small Bathers,* fall 1896–spring 1897, lithograph, first state, 232 x 292 mm., Yale University Art Gallery: Bequest of Ralph Kirkpatrick, Hon. M.A. 1965

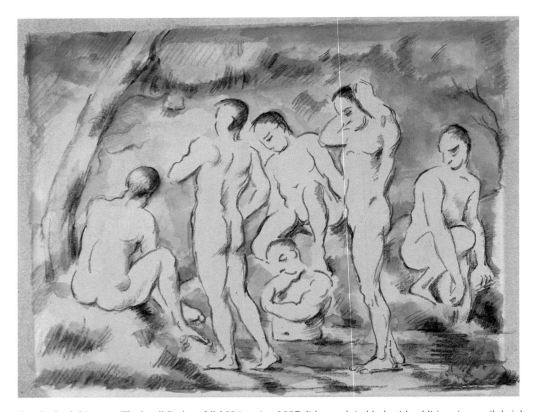

Cat. 5. Paul Cézanne, *The Small Bathers,* fall 1896–spring 1897, lithograph in black with additions in pencil, heightened with watercolor, 232 x 288 mm., Gecht Family Collection, Chicago

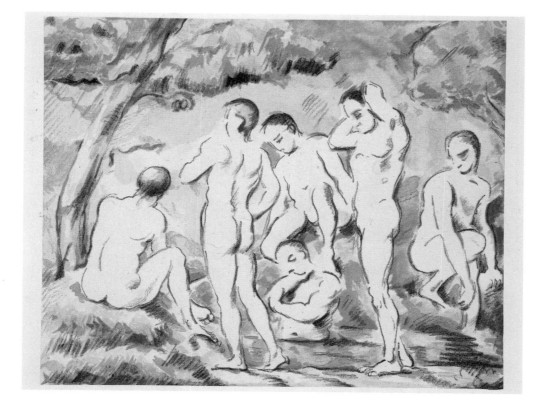

Cat. 6. Paul Cézanne, *The Small Bathers,* fall 1896–spring 1897, from *L'Album d'estampes originales de la galerie Vollard,* 1897; lithograph in green, yellow, pink, and blue, third state, 224 x 273 mm., courtesy of the Fogg Art Museum, Harvard University Art Museums, Horace Swope Fund. Photo: David Mathews, ©President and Fellows of Harvard College, Harvard University

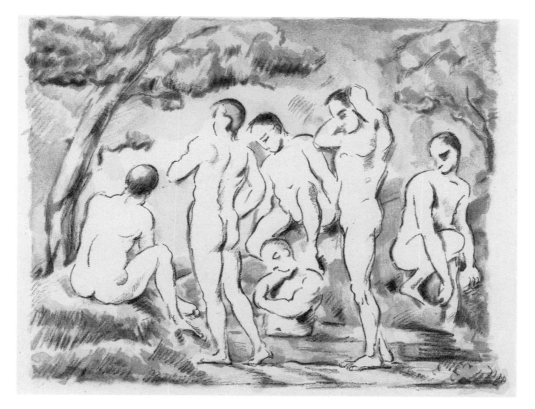

Cat. 7. Paul Cézanne, *The Small Bathers,* fall 1896–spring 1897, lithograph in green, yellow, pink, and blue, fourth state, 230 x 270 mm., Yale University Art Gallery, Bequest of Ralph Kirkpatrick, Hon. M.A. 1965

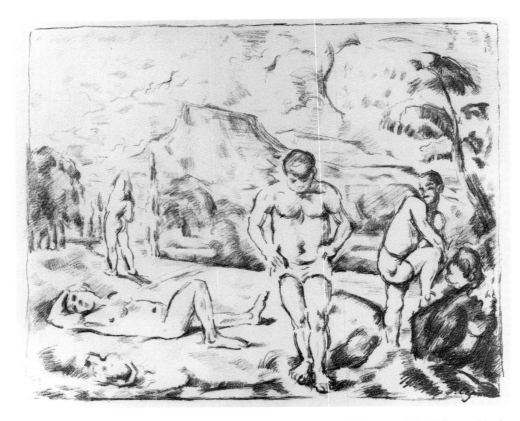

Cat. 8. Paul Cézanne, *The Large Bathers*, fall 1896–spring 1897, lithograph, first state, 410 x 510 mm., Mead Art Museum, Amherst College, Purchase 1954.41. Photo: Stephen Petegorsky

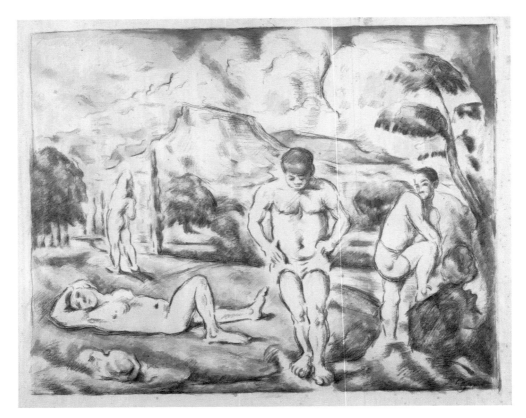

Cat. 9. Paul Cézanne, *The Large Bathers*, 1896–1898, lithograph in black heightened with watercolor, 410 x 510 mm., National Gallery of Canada, Ottawa (Purchase, 1970)

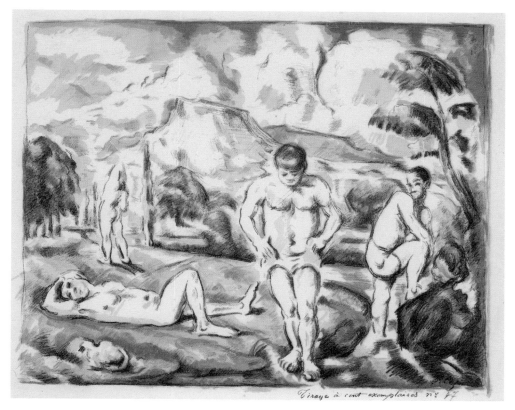

Cat. 10. Paul Cézanne, *The Large Bathers*, 1896–1898, lithograph in ochre, blue, green, yellow, rose, and orange, second state, 410 x 510 mm., The Metropolitan Museum of Art, Rogers Fund, 1922

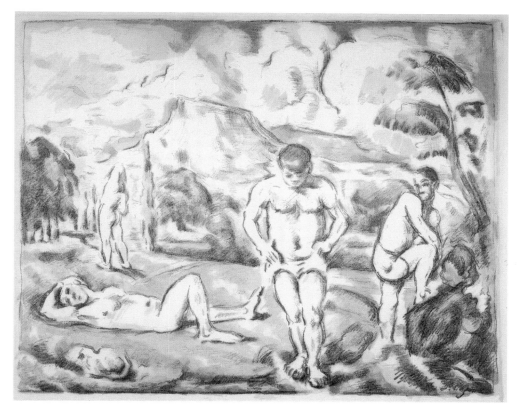

Cat. 11. Paul Cézanne, *The Large Bathers*, 1896–1898, lithograph in ochre, blue, green, yellow, and rose, third state, 413 x 511 mm., Smith College Museum of Art, Northampton, Massachusetts, purchased with funds provided by the Chace Foundation, Inc. [Mrs. Malcolm G. Chace, Jr. (Beatrice Ross Oenslager, Class of 1928)], 1957

based on Cézanne's well-known painting of 1876–77 *Bathers at Rest* (Fig. 23). In the late 1890s, this was Cézanne's most famous work, known since it appeared in the 1877 Impressionist Exhibition, where it provoked both angry and admiring commentary.[115] One of the most controversial works in the 1893 bequest to the state on the death of the painter Gustave Caillebotte, it was placed on view in Vollard's shop window at the time of the 1895 Cézanne retrospective. The painting included two of the major themes in Cézanne's *oeuvre*: the bathers and Mont Sainte-Victoire. Vollard liked the famous work; it was a logical choice as a subject for a lithograph by the artist.

The *Small Bathers* (Cat. 4) was drawn directly on the stone. While it can be related to such works as *The Seven Bathers* (Fig. 24), it is not based on any one work directly, but, rather, is simply one in a series of male bather compositions executed by Cézanne in the 1890s. Thus, Cézanne was not hampered by the need to work in reverse in the creation of this print.

The *Large Bathers* and the *Portrait of Cézanne* are more fully conceived as independent works in black and white, whereas the more simplified drawing of *The Small Bathers* keystone seems to need color to "finish" it. This led Druick to the conclusion that *The Large Bathers* and the *Portrait of Cézanne* may have only been intended as black and white lithographs.[116] Responding to Vollard's growing preference for the more salable color prints, Cézanne undertook *The Small Bathers*, a work intended from the start to be published as a color lithograph. According to Druick, the black and white keystones of *The Large Bathers* and the *Portrait of Cézanne* were executed before the black and white keystone, the *maquettes*, and the color lithograph of *The Small Bathers*. Since the latter appeared in Vollard's second album in December 1897, all of these works must be dated to before that time. The color *maquettes* of *The Large Bathers* and the *Portrait of Cézanne*, according to Druick, were probably not done until the summer of 1898 when Cézanne was in Paris again and able to work directly with Clot and Vollard.[117]

Issues of chronology aside, what is most interesting about Cézanne's prints is the process by which the color stones and the final color prints were created. In each case the artist prepared colored models, or *maquettes,* by hand-coloring impressions of the black and white keystone in watercolor. These were then used to guide the printer as he prepared the color stones. The same process was used by Renoir when he collaborated with Vollard and Clot in the preparation of his large color lithograph *The Pinned Hat* (Cat. 37).[118] The *maquette*, prepared by Renoir using an impression of the black and white keystone, was done in pastel and watercolor.

In the preparation of Cézanne's color lithographs, the artist executed varying numbers of *maquettes* for each print. Only one is known for the *Portrait of Cézanne*

(Cat. 12), the only print which was not carried out as a color lithograph. For the *Small Bathers* (Cats. 6, 7), there is only one surviving *maquette* (Cat. 5). However, the differences that exist between this *maquette* and the color states of the print indicate the probability of other *maquettes* prepared by Cézanne to assist Clot in the execution of the color print. The *maquette* in the collection of the National Gallery of Canada (Cat. 9) is one of five existing *maquettes*, three of which are by Cézanne, for *The Large Bathers* (Cats. 10, 11).[119] There are also noticeable differences between the *maquette* (Cat. 9) and the colored states of the print. Most obvious is the use of ochre in the print where, in the *maquette*, there is a predominance of blue. The reason for this substitution is uncertain, but the change was probably not done without Cézanne's approval.

Druick notes that the later states of both the *Small Bathers* and the *Large Bathers* (Cats. 7, 11) are lighter and more translucent than the earlier states, indicating adjustments by Clot in his attempt to achieve the effect of the watercolor *maquette*.[120] Each state shows differences in color; there are also differences in color from one impression to the next. That each impression and each state has unique effects is a testament to Clot's untiring efforts to pursue Cézanne's original intent.

Thus, here as in his earlier involvement as a maker of prints, Cézanne is revealed as an artist capable and willing to engage with others in the creative act. Motivated more by a desire for friendship, artistic support, and validation than by he medium itself, Cézanne nevertheless demonstrated a surprising commitment to the collaborative nature of the printmaker's task. The study of Cézanne's prints gives us greater insight into several important figures in his life, and it uncovers new aspects of the relationships he developed through his collaboration with these individuals. In examining his printmaking activity, seldom acknowledged dimensions of his art and person are brought to light, adding depth and balance to our understanding of Cézanne and his *oeuvre*.

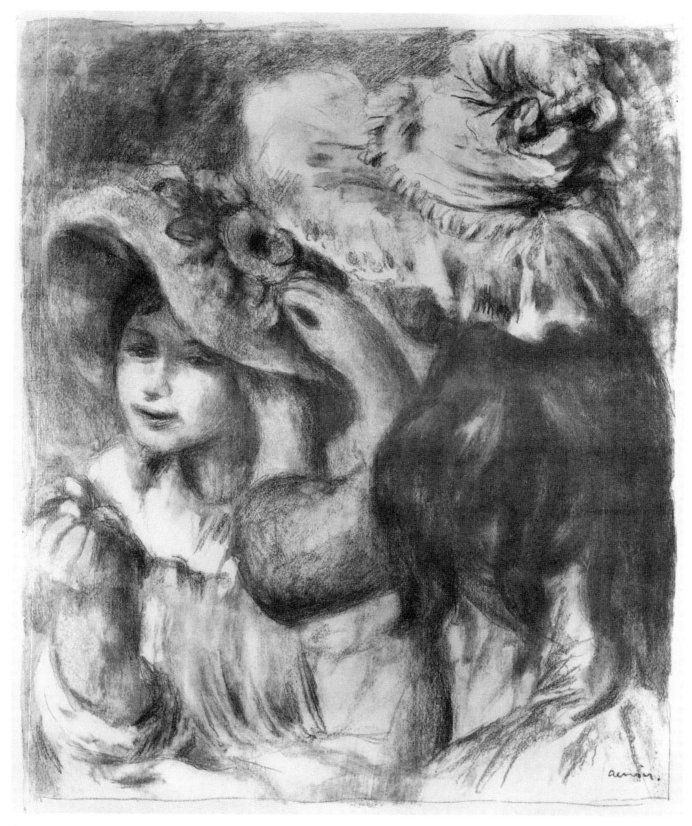

Cat. 37. Pierre-Auguste Renoir, *The Pinned Hat,* 1898, lithograph in yellow, red, green, orange, gray, pink, blue, brown, and black, 608 x 495 mm. (image), Smith College Museum of Art, Northampton, Massachusetts, Gift of Mrs. John Wintersteen (Bernice McIlhenny, Class of 1925)

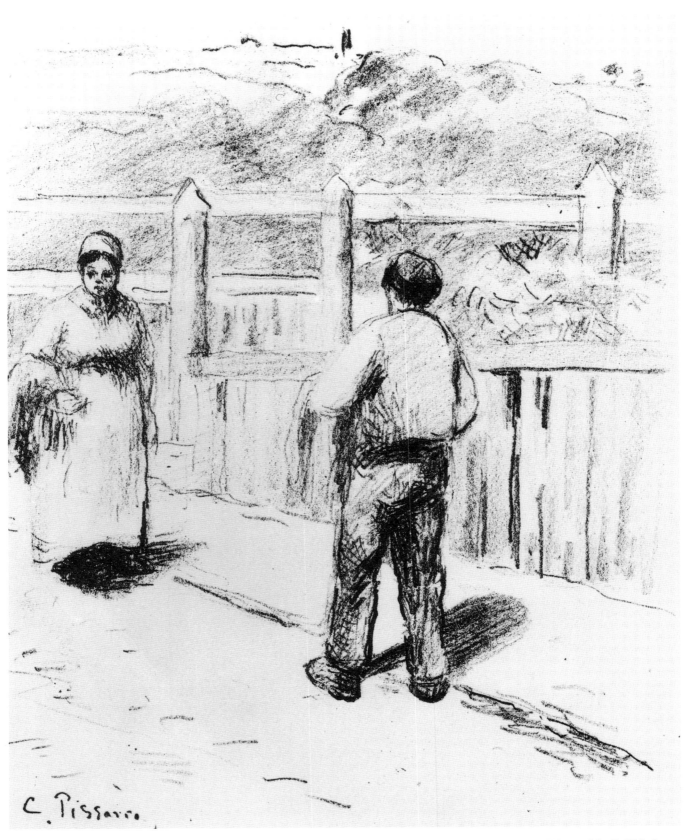

C. Pissarro

Cat. 32. Camille Pissarro, *A Street at Les Pâtis, near Pontoise,* 1874, lithograph, 265 x 220 mm., S. P. Avery Collection, Miriam and Ira D. Wallach Division of Art, Prints and Photographs, The New York Public Library, Astor, Lenox and Tilden Foundation

Notes

[1] Joseph Rishel, *Cézanne in Philadelphia Collections*, exh. cat., Philadelphia Museum of Art, Philadelphia, 1983, p. 80.

[2] For discussion of *The House of the Hanged Man, Auvers-sur-Oise*, see John Rewald in collaboration with Walter Feilchenfeldt and Jayne Warman, *The Paintings of Paul Cézanne, A Catalogue Raisonné*, New York, 1996, vol. 1, no. 202, p. 152, 153; and Françoise Cachin et al., *Cézanne*, exh. cat., Paris, Galeries Nationales du Grand Palais; London, Tate Gallery; Philadelphia Museum of Art, Philadelphia, 1996, cat. no. 30, p. 139.

[3] Claudia Rousseau, "Cézanne, Dr. Gachet, and the Hanged Man," *Source: Notes in the History of Art*, vol. 6, no. 1, fall 1986, p. 31

[4] Rousseau, 1986, pp. 31, 33.

[5] On Cézanne's relationship with Pissarro, see, most recently, Richard Brettell, "Cézanne/Pissarro: élève/élève," in *Cézanne aujourd'hui, Actes du colloque organisée par le musée d'Orsay, 29 et 30 novembre 1995*, eds. Françoise Cachin, Henri Loyrette, Stéphane Grégan, Paris, 1997, pp. 29–37; Barbara Erhlich White, "Cézanne & Pissarro," in *Impressionists Side by Side. Their Friendships, Rivalries, and Artistic Exchanges*, New York, 1996, pp. 107–148. Also, see note 61 below.

[6] Works from the collection of Dr. Gachet given to the French government and now in the Musée d'Orsay and the Bibliothèque nationale are the subject of a major 1999 international exhibition, *La collection Gachet*, Paris, Musée d'Orsay (January 25 to April 25) and New York, Metropolitan Museum of Art (May–August).

[7] See Rewald et al., 1996, nos. 184–227, 232.

[8] William Rubin, ed., *Cézanne, The Late Work*, exh. cat., Museum of Modern Art, New York, 1977 (see note 14 below); Françoise Cachin et al., 1996.

[9] The exhibition took place from May 30 to August 15, 1972 in Aix-en-Provence at the Palais Vendome. A small catalogue with introduction by Michel Melot was published in conjunction with the exhibition, *Cézanne, l'oeuvre gravé*, Aix-en-Provence, 1972.

[10] Lionello Venturi, *Cézanne, son art—son oeuvre*, Paris, 1936, vol. 2, nos. 1159 (*Guillaumin au Pendu*); 1160 (*Tête de Femme*); 1161 (*Paysage à Auvers*). These are Cat. nos. 1, 2, 3.

[11] Paul Gachet, *Cézanne à Auvers, Cézanne graveur*, Paris, 1952, n.p. *Péniches sur la Seine à Bercy; Vue dans un jardin à Bicêtre*. See figs. 15, 19. These works exist in unique impressions at the Bibliothèque nationale. They were not available for loan.

[12] Gachet, 1952.

[13] On the etchings, see in particular by Melot, *Cézanne, l'oeuvre gravé*, Aix-en-Provence, 1972; *L'Estampe impressioniste*, exh. cat., Bibliothèque nationale, Paris, 1974, pp. 131–133; chap. 22, "1873: The Auvers Group," in Michel Melot, *The Impressionist Print*, trans. Caroline Beamish, New Haven and London, 1996, pp. 102–107 (Eng. ed. of *L'Estampe impressionniste*, Paris, 1994).

[14] Douglas Druick, "Cézanne's Lithographs," in Rubin, ed., 1977, pp. 119–137; Also, Douglas Druick, "Cézanne, Vollard, and Lithography: The Ottawa maquette for the 'Large Bathers' Colour Lithograph," *National Gallery of Canada Bulletin*, vol. 19, 1972 (1974), pp. 2–34.

[15] Druick, 1977, 126.

[16] André Mellerio, *La Lithographie originale en couleurs*, Paris, 1898, trans. Margaret Needham; reprinted in Phillip Dennis Cate and Sinclair Hamilton Hitchings, *The Color Revolution, Color Lithography in France 1890–1900*, exh. cat., Rutgers University Art Gallery, 1978, pp. 87, 89; Druick, 1977, pp. 126, 136, note 70.

[17] Druick, 1977, p. 126.

[18] Druick, 1977, p. 126, 136, note 74.

[19] Druick, 1977, p. 126.

[20] On the lithographs, Cézanne, and Vollard, see Una E. Johnson, *Ambroise Vollard, Editeur: Prints, Books, Bronzes*, New York, 1977 and Michel Melot, chap. 57, "Vollard and the Impressionists," in Melot, 1996, pp. 263–266.

[21] Rousseau, 1986; Melot, 1996.

[22] Melot, 1996, p. 106.

[23] On Cézanne's copies, see Guila Ballas, "Daumier, Corot, Papety et Delacroix, inspirateurs de Cézanne," *Bulletin de la Société l'Histoire de l'Art français*, année 1974 (1975), pp. 193–199; Roger Benjamin, "Recovering Authors: The Modern Copy, Copy Exhibitions, and Matisse," *Art History*, vol. 12, no. 2, June 1989, p. 188; Gertrude Berthold, *Cézanne und die alten Meister*, Stuttgart, 1958; Adrien Chappuis, *The Drawings of Paul Cézanne, A Catalogue Raisonné*, 2 vols., Greenwich, Ct, 1973; and further references cited in Richard Shiff, *Cézanne and the End of Impressionism*, Chicago and London, 1986, p. 290, note 46.

[24] *La Conversation*, 1870–71; *La Promenade*, 1871; see Rewald et al., 1996, nos. 152, 153, pp. 127–28. On the association between contemporary popular broadsides, penny prints, and *canards* with violent themes and Cézanne's early paintings of similar subjects see Robert Simon, "Cézanne and the Subject of Violence," *Art in America*, vol. 79, no. 5, May 1991, pp. 120–135, 185, 186.

[25] Theodore Reff, "Reproductions and Books in Cézanne's Studio," *Gazette des Beaux-Arts*, vol. 56, November 1960, p. 303.

[26] Reff, 1960, pp. 303–06.

[27] Reff, 1960, pp. 304, 308, note 13.

[28] See Chappuis, 1973, for drawings after Marcantonio Raimondi, nos. 87, 481; after Goya, no. 405; after Delacroix, nos. 325, 326; On the painting after Ostade's print *The Family*, see Rewald et al., 1996, no. 589.

[29] Emile Bernard, *Souvenirs sur Paul Cézanne et Lettres*, Paris, 1921, p. 50.

[30] Bernard, 1921, 50.

[31] Patricia Phagan, ed., *Adriaen van Ostade: Etchings of Peasant Life in Holland's Golden Age*, exh. cat., Georgia Museum of Art, University of Georgia, Athens, 1994, p. 229.

[32] Fritz Novotny, "Zu einer 'Kopie' von Cézanne nach Ostade," *Pantheon*, vol. 25, no. 4, July–August 1967, 280; Rewald et al., 1996, p. 395.

[33] Reff, 1960, p. 306.

[34] Reff, 1960, p. 304, nos. 27, 28. These are respectively, nos. 91 and 126 in the catalogue of Delacroix's prints by Loys Delteil, *Le Peintre-gravure illustré*, vol. 3: *Ingres & Delacroix*, Paris, 1908.

35 Delacroix's lithograph, *Hamlet Contemplating the Skull of Yorick* is Delteil 75. On the drawings by Cézanne, see Chappuis, 1973, nos. 325, 326. On the Cézanne oil on paper, see Rewald et al., no. 232 and Lionello Venturi, "*Hamlet and Horatio, A Painting by Paul Cézanne*," *Art Quarterly*, vol. 19, no. 3, Autumn 1956, pp. 270–271. The painting, formerly owned by Dr. Gachet, is now in a private Philadelphia collection.

36 On the theme of death in Cézanne's art, see Theodore Reff, "Cézanne: The Severed Head and the Skull," *Arts Magazine*, vol. 58, no. 2, October 1983, pp. 85–100.

37 See Chappuis, 1973, nos. 325, 326, p. 118; Gachet, 1952, p. 12.

38 Wayne Andersen, *Cézanne's Portrait Drawings*, Cambridge, Mass. and London, 1970, p. 12.

39 Andersen, 1970, p. 12.

40 In addition to Cézanne and Guillaumin, others were Victor Vignon, Frédéric Cordey, Ludovic Piette, Edouard Béliard, and Francisco Oller. See Ralph Shikes and Paula Harper, "Pissarro and the School of Pontoise," chap. 10 in *Pissarro: His Life and Work*, New York, 1980, pp. 115–130; Kathleen Adler, *Camille Pissarro, A Biography*, New York, 1977, p. 53.

41 Letter of 27 March 1872 in Paul Cézanne, *Letters*, rev. and aug. ed., John Rewald, ed., trans. Seymour Hacker, New York, 1984, p. 139.

42 Jules Borély, "Cézanne à Aix," *L'Art vivant*, no. 37, 1 July 1926, pp. 491–93, in P. M. Doran, ed., *Conversations avec Cézanne*, Paris, 1978, p. 21.

43 Pissarro to Guillemet, Paris, 3 September 1872, quoted in John Rewald, *Cézanne, A Biography*, New York, 1986, p. 95.

44 Paul Gachet, *Deux amis des Impressionnistes: le docteur Gachet et Murer*, Paris, 1956, pp. 28, 29.

45 Rousseau, 1986, p. 30, where other aspects of Gachet's personality and interests are also discussed. Also useful for biographical information are: Victor Doiteau, "La Curieuse Figure du Dr. Gachet: Un ami et un amateur de la première heure de Cézanne, Renoir, Pissarro, van Gogh," *Aesculape*, August 1923, pp. 169–173; September 1923, pp. 211–216; November 1923, pp. 250–254; December 1923, pp. 278–283; January 1924, pp. 7–11; Gachet, 1956; L. Trenard, "Gachet," *Dictionnaire de Biographie française*, vol. 14, Paris, 1976, pp. 1526–1527; U. F. Vanderbroucke and J. Sonolet, *Qui était le Docteur Gachet?*, Auvers-sur-Oise, 1980.

46 Gachet, 1956, p. 19.

47 Gachet, 1956, p. 15.

48 John Rewald, "Gachet's Unknown Gems Emerge," *Art News*, vol. 51, March 1952, p. 63.

49 Paul Gachet, "Les Chats," *Paris à l'eau-forte*, no. 7, 11 May 1873, pp. 97–112.

50 On van Gogh in Auvers and the association between van Gogh and Dr. Gachet, see Vincent van Gogh, *The Complete Letters of Vincent van Gogh*, 2nd. ed., with preface and memoir by Johanna van Gogh-Bonger, Greenwich, Ct., 1958, vol. 3, Letters from Auvers-sur-Oise, no. 635 ff.; Ronald Pickvance, *Van Gogh in Saint-Rémy and Auvers*, exh. cat., Metropolitan Museum of Art, New York, 1986; Carol Zemel, chap. 6 "'The Real Country': Utopian Decoration in Auvers," in *Van Gogh's Progress, Utopia, Modernity, and Late-Nineteenth-Century Art*, Berkeley, Los Angeles, New York, 1997, pp. 107–245. Dr. Gachet gained instantaneous fame in May 1990 when a portrait of him by Van Gogh sold at Christies, New York for $82.5 million, the highest price ever paid for a painting at auction. See Cynthia Saltzman, *Portrait of Dr. Gachet: The Story of a Van Gogh Masterpiece*, New York, 1998.

51 Letter no. 635, Vincent van Gogh, 1958, vol. 3, p. 273.

52 Rewald, 1986, 95.

53 Paul van Ryssel (Dr. Gachet), "Valmondois, Enterrement civil d'Honoré Daumier," *Le Patriote de Pontoise*, 16 February 1879, reprinted in Gachet, 1956, pp. 22–23.

54 See letter from Pissarro to his son Lucien from Paris, 22 November 1895, in Camille Pissarro, *Letters to his Son Lucien*, ed. John Rewald, New York, 1995, p. 276.

55 Gachet, 1956, p. 29. For response of Louis-Auguste Cézanne, Aix, 10 August 1873, see Cézanne, *Letters*, 1984, p. 142.

56 Lawrence Gowing, *Paul Cézanne: The Basel Sketchbooks*, exh. cat., Museum of Modern Art, New York, 1988, p. 18.

57 Chappuis, 1973, nos. 293, 299, 300, 301. Also, see White, 1996, pp. 140–145.

58 Emile Bernard, "Paul Cézanne," *Les Hommes d'aujourd'hui*, vol. 8, no. 387, 1891; *Paul Cézanne*, Paris, Galerie Ambroise Vollard, November–December, 1895.

59 Camille Pissarro, *Portrait of Paul Cézanne*, 1874, oil on canvas, Collection of Laurence Graff, color illus. in White, 1996, p. 144. Ludovico-Rodo Pissarro and Lionello Venturi, *Camille Pissarro: son art—son oeuvre*, 2 vols., 1939, no. 293. (cat. nos. from this source indicated as P&V #).

60 For the interpretation of the background images, see Theodore Reff, "Pissarro's Portrait of Cézanne," *The Burlington Magazine*, vol. 109, November 1967, pp. 627–633.

61 In addition to sources cited in note 5, see Joachim Pissarro, *Camille Pissarro*, New York, 1993, pp. 90–106; Christopher Lloyd, "Paul Cézanne, 'Pupil of Pissarro,' An Artistic Friendship," *Apollo*, vol. 136, November 1992, pp. 284–290; Richard Brettell, "Pissarro, Cézanne, and the School of Pontoise," in Richard Brettell et al., *A Day in the Country, Impressionism and the French Landscape*, New York, 1990 (1984), pp. 175–205; Christopher Lloyd, *Camille Pissarro*, Geneva, 1981, pp. 62–72; Shikes and Harper, "Pissarro, Cézanne and the School of Pontoise," 1980, pp. 115–30; Theodore Reff, "Cézanne's Constructive Stroke," *Art Quarterly*, vol. 25, no. 3, autumn 1962, pp. 214–27.

62 Melot, 1974, p. 131.

63 Venturi, 1936, no. 1159.

64 Rishel, 1983, 80.

65 According to Henri Loyrette, "No hanged man has ever set foot there." See Cachin et al., 1996, p. 139.

66 Rousseau, 1986, p. 33.

67 Rousseau, 1986, pp. 33, 34.

68 Rousseau, 1986, p. 32.

69 Rousseau, 1986, p. 32.

70 Rousseau, 1986, p. 33.

71 Rousseau, 1986, p. 33.

72 Rousseau, 1986, p. 31.

73 Guillaumin's painting, *The Seine at Bercy* is now in the Kunsthalle, Hamburg. Cézanne's painting after this work was done around 1876–78. See Rewald et al., 1996, no. 293, pp. 199–201. On the friendship between Cézanne and Guillaumin, see John Rewald, "Cézanne and Guillaumin," in *Studies in Impressionism*, eds., Irene Gordon and Frances Weitzenhoffer, New York, 1985, pp. 103–119.

74 See Richard Brettell, "The Industrial Landscape: Pissarro and the Factory," chap. 3 in *Pissarro and Pontoise: The Painter in a*

Landscape, New Haven and London, 1990, pp. 73–97.

[75] Camille Pissarro, *Factory at Pontoise* (P&V 217); Brettell, 1990, Fig. 74, p. 84. The work is now in the National Gallery of Canada.

[76] *La Route de Rouen: Les hauteurs de l'Hautil, Pontoise* (Delteil 11), is based on the painting of same name (P&V 151), private collection, Dallas; Brettell, 1990, fig. 121.

[77] Melot, 1996, p.106.

[78] A. B., "Promenade fantaisiste," *Paris à l'eau-forte,* no. 32, 2 November 1873, pp. 197-203.

[79] A. B., "Promenade fantaisiste," 1873, p. 198.

[80] A. B., "Promenade fantaisiste," 1873, p. 199.

[81] Charles Baudelaire, "Peintres et Aqua-fortistes," *Le Boulevard,* 14 September 1862; reprinted and translated as "Painters and Etchers," in Jonathan Mayne, ed., *Art in Paris 1845–1862: Salons and Other Exhibitions Reviewed by Charles Baudelaire,* London, 1965, pp. 220, 221.

[82] Victorine Hefting, *Jongkind, sa vie, son oeuvre, son époque,* Paris, 1975, pp. 48, 368.

[83] Zola's essay "Jongkind" is reprinted Hefting, 1975, p. 369 and discussed pp. 47–48.

[84] The relation of this work to Jongkind is noted by Loyrette in Cachin et al., 1996, no. 26, p. 131. Also, see Rewald et al., no. 179.

[85] Gachet's print is illustrated in Chappuis, 1973, under Cézanne's lost drawing *L'Estaque,* 1872–73, no. 124A, p. 76.

[86] See Chappuis, 1973, no, 278; Cachin et al., 1996, *Peasant Girl Wearing a Fichu,* c. 1873, Philadelphia Museum of Art, no. 33, p. 144. The early date of this work has been challenged. See Theodore Reff, "Cézanne's Drawings," *The Burlington Magazine,* vol. 117, no. 868, July 1975, p. 490.

[87] Melot, 1996, p. 105.

[88] Baudelaire, "Painters and Etchers," in Mayne, 1965, p. 219.

[89] Douglas Druick and Peter Zegers, "Degas and the Printed Image, 1856–1914," in Sue Welsh Reed and Barabara Stern Shapiro, *Edgar Degas: The Painter as Printmaker,* exh. cat., Museum of Fine Arts, Boston, 1984, p. xxxiii.

[90] Druick and Zegers, 1984, p. xxxiii.

[91] Letter from Victor Hugo, 12 April 1873, reprinted in *Paris à l'eau-forte,* no. 8, 18 May 1873, p. 117.

[92] Or, according to Melot, 1996, p. 103, it could have been that they did not want them published in *Paris à l'eau-forte* for political reasons. Issue no. 18, 27 July 1873, included a tribute and an etched portrait of Mac-Mahon.

[93] Alison McQueen, *The Modern Artist and the Old Master: The Reinvention of Rembrandt in France 1850–1900,* Ph.D. diss., University of Pittsburgh, 1998, p. 207.

[94] Paul Gachet,"Les Chats," *Paris à l'eau-forte,* no. 7, 11 May 1873, pp. 97–112.

[95] See Cat. nos. 15–22.

[96] Richard Lesclide, "Epilogue P. P. C.," *Paris à l'eau-forte,* no. 18, 27 July 1873, p. 287.

[97] Lesclide, "Epilogue P. P. C.," p. 287.

[98] Lesclide, "Epilogue P. P. C.," p. 287.

[99] Richard Lesclide, "Eaux-fortes de cette livraison," *Paris à l'eau-forte,* no. 56, 3 May 1874, p. 28.

[100] Lesclide, "Eau-fortes de cette livraison," 1874, p. 28.

[101] Charles de Malte (pseudonym of Auguste Villiers de l'Isle-Adam), "Exposition de la Société anonyme des artistes peintres, sculpteurs, graveurs et lithographes," *Paris à l'eau-forte,* no. 54, 19 April 1874, pp. 12–13.

[102] Richard Lesclide, "Une Soirée chez Victor Hugo," *Paris à l'eau-forte,* no. 40, 28 December 1873, pp. 65–76.

[103] Druick and Zegers, 1984, pp. xxxi, xxxii, lii, note 21.

[104] *The Railway Crossing at Les Pâtis, near Pontoise,* 1873-74, oil on canvas, 650 x 810 mm., Phillips Family Collection (P&V 266). The painting was begun in 1873 and repainted in 1874. Considered by Brettell as "among the greatest French landscapes of the mid-1870s," this and related works indicate Pissarro's "suspicion of and possible opposition to the railroad." See Brettell, 1990, pp. 65, 67; fig. 65, p. 70.

[105] On color lithography in the 1890s, see Cate and Hitchings, 1978.

[106] Entitled *Quelques Aspects de la vie de Paris.*

[107] From article of 5 December 1895, by Arsène Alexandre, "Claude Lantier," quoted in Rewald, 1986, pp. 208–09. Claude Lantier was the protagonist of the 1886 novel by Emile Zola, *L'Oeuvre.*

[108] Ambroise Vollard, *Recollections of a Picture Dealer,* trans. Violet M. MacDonald, New York, 1978 (1936), p. 70.

[109] Cézanne's celebrated 1899 *Portrait of Vollard,* Paris, Petit Palais, was executed, according to Vollard, in 115 sittings. (Rewald et al., no. 811). Picasso and Bonnard also did portraits of Vollard.

[110] Druick, 1977, p. 120.

[111] Druick, 1977, p. 120.

[112] See Cézanne letters to Vollard from 1901–03, in Cézanne, 1984, pp. 273, 276, 277, 281–83, 289. Vollard's biography of *Paul Cézanne* was published in 1914. Also by Vollard, "Souvenirs sur Cézanne," *Cahiers d'Art,* vol. 6, nos. 9–10, 1931, pp. 386–395.

[113] Druick, 197, pp. 123ff.

[114] Druick, 1977, p. 126.

[115] On the *Bathers at Rest,* see Rewald et al., 1996, no. 261, pp. 179–180.

[116] Druick, 1977, pp. 127, 128.

[117] Druick, 1977, p. 128.

[118] One of four Renoir lithographs of 1898, the print represents Julie Manet, the daughter of the painter Berthe Morisot, and Julie Manet's cousin.

[119] Druick, 1977, 120, note 102.

[120] Druick, 1977, 137.

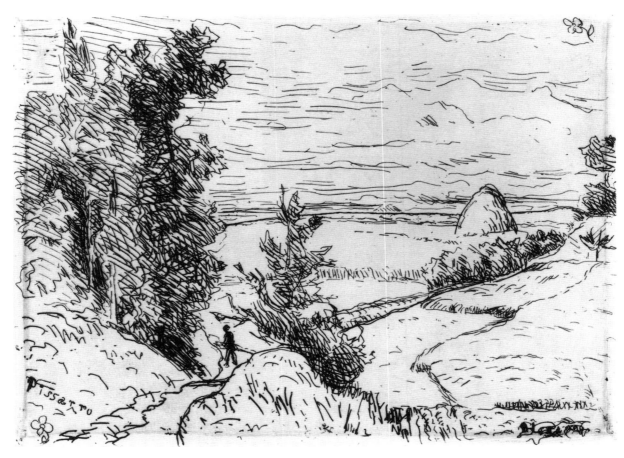

Cat. 27. Camille Pissarro, *Hills at Pontoise,* 1873, etching, 120 x 160 mm., S. P. Avery Collection, Miriam and Ira D. Wallach Division of Art, Prints and Photographs, The New York Public Library, Astor, Lenox and Tilden Foundation

Following the prints by Paul Cézanne, the checklist is arranged alphabetically by artist. Dimensions are given in millimeters with height preceding width. Measurements are given for plate or stonemark unless otherwise indicated. Abbreviated references are given in full in the bibliography.

PAUL **CEZANNE**
French, 1839–1906

1. *Portrait of Guillaumin with the 'Hanged Man' (Guillaumin au pendu)*, 1873
 Etching on laid paper
 153 x 113 mm.
 Posthumous edition
 Venturi 1159; Cherpin 2; Leymarie/Melot C2;
 Salamon 2
 Mead Art Museum, Amherst College
 Purchase, William K. Allison (Class of 1920) Memorial
 Fund
 (illus. p. 8)

2. *Head of a Young Girl (Tête de jeune fille)*, September 1873
 Etching with roulette, printed in dark brown on wove paper, third state
 Signed in plate, lower right: *73/ P. Cézann* (final 'e' cropped)
 124 x 98 mm.
 Posthumous edition of 1000, printed as frontispiece to *Paul Cézanne* by Ambroise Vollard, Paris, 1914
 Venturi 1160; Cherpin 4 iii/iii; Leymarie/Melot C4;
 Salamon 4
 Mead Art Museum, Amherst College
 Purchase, Charles H. Morgan Fund
 (illus. p. 32)

3. *Landscape at Auvers, Entrance to the Farm, Rue Rémy (Paysage à Auvers, Entrée de ferme, rue Rémy)*, July 1873
 Etching on wove paper
 134 x 111 mm.
 Posthumous edition of 600, printed as frontispiece to *Cézanne*, edited by Bernheim-Jeune, Paris, 1914
 Venturi 1161; Cherpin 5; Leymarie/Melot C5; Salamon 5
 Smith College Museum of Art, Northampton, Massachusetts
 Gift of Abraham Kamberg
 (illus. p. 31)

4. *The Small Bathers (Les Petits Baigneurs)*, fall 1896–spring 1897
 Lithograph in black on *chine volant*, first state
 232 x 292 mm.
 Printer: Auguste Clot, Paris
 Publisher: Ambroise Vollard, Paris
 Venturi 1156; Cherpin 6, i/ii; Leymarie/Melot C8;
 Druick III, i/iv
 Yale University Art Gallery
 Bequest of Ralph Kirkpatrick, Hon. M.A. 1965
 (illus. p. 42)

5. *The Small Bathers (Les Petits Baigneurs)*, fall 1896–spring 1897
 Lithograph in black with additions in pencil, heightened with watercolor on wove paper
 232 x 288 mm.
 Printer: Auguste Clot, Paris
 Venturi 1156; Cherpin 6; Leymarie/Melot C8; Druick III
 Gecht Family Collection, Chicago
 (illus. p. 42)

6. *The Small Bathers (Les Petits Baigneurs)*, fall 1896–spring 1897
 From *L'Album d'estampes originales de la galerie Vollard*, 1897
 Lithograph in green, yellow, pink, and blue on *chine collé*, third state
 Signed in stone, below composition, lower right: *P. Cézanne*
 224 x 273 mm.
 Edition of 1897, 100 impressions
 Printer: Auguste Clot, Paris
 Publisher: Ambroise Vollard, Paris
 Venturi 1156; Cherpin 6, ii/ii; Leymarie/Melot C8;
 Johnson 23;
 Druick III, iii/iv
 Fogg Art Museum, Harvard University Art Museums
 Horace Swope Fund
 (illus. p. 43)

7. *The Small Bathers (Les Petits Baigneurs)*, fall 1896–spring 1897
 Lithograph in green, yellow, pink, and blue on laid paper, fourth state
 230 x 270 mm.
 Edition: probably posthumous, possibly 1914
 Printer: Auguste Clot, Paris
 Publisher: Ambroise Vollard, Paris
 Venturi 1156; Cherpin 6, ii/ii; Leymaire/Melot C8;
 Johnson 23; Druick III, iv/iv
 Yale University Art Gallery
 Bequest of Ralph Kirkpatrick, Hon. M.A. 1965
 (illus. p. 43)

8. *The Large Bathers (Les Grands Baigneurs)*, fall 1896–spring 1897
 Lithograph in black on laid paper, first state
 Signed in stone, lower right: *P. Cézanne*
 410 x 510 mm.
 Edition: possibly 1898
 Printer: Auguste Clot, Paris
 Publisher: Ambroise Vollard, Paris
 Venturi 1157; Cherpin 7, i/iii; Leymarie/Melot C6;
 Druick I, i/iii
 Mead Art Museum, Amherst College
 Purchase
 (illus. p. 44)

9. *The Large Bathers (Les Grands Baigneurs)*, 1896–1898
 Lithograph in black heightened with watercolor on laid paper
 Signed in stone, lower right: *P. Cézanne*
 410 x 510 mm.
 Printer: Auguste Clot, Paris
 Venturi 1157; Cherpin 7; Druick I
 The National Gallery of Canada, Ottawa
 Purchase, 1970
 (illus. p. 44)

10. *The Large Bathers (Les Grands Baigneurs)*, 1896–1898
 For unpublished *L'Album d'estampes originales de la
 Galerie Vollard*, 1898 Lithograph in ochre, blue, green,
 yellow, rose, and orange on Arches Ingres paper, second
 state
 Inscription and signature in the stone, lower right: *Tirage
 à ent exemplaires No /P. Cézanne*
 410 x 510 mm.
 Edition: probably 1898, no. 47 of at least 100
 impressions
 Printer: Auguste Clot, Paris
 Publisher: Ambroise Vollard, Paris
 Venturi 1157; Cherpin 7, iii/iii; Leymarie/Melot 6;
 Johnson 23; Druick I, ii/iii
 The Metropolitan Museum of Art
 Rogers Fund, 1922
 (illus. p. 45)

11. *The Large Bathers (Les Grands Baigneurs)*, 1896–1898
 Lithograph in ochre, blue, green, yellow, and rose on
 laid paper, third state
 Signed in stone, lower right: *P. Cézanne*
 413 x 511 mm.
 Edition: probably posthumous, possibly 1914 of at least
 100 impressions
 Printer: Auguste Clot, Paris
 Publisher: Ambroise Vollard, Paris
 Venturi 1157; Cherpin 7, ii/iii; Leymarie/Melot C6;
 Johnson 23; Druick I, iii/iii
 Smith College Museum of Art, Northampton, Massachu-
 setts
 Purchased with funds provided by the Chace Foundation,
 Inc.
 [Mrs. Malcolm G. Chace, Jr. (Beatrice Ross Oenslager,
 Class of 1928)], 1957
 (illus. p. 45)

12. *Portrait of Cézanne (Portrait de Cézanne)*, 1896–1897
 For unpublished *L'Album d'estampes originales de la
 Galerie Vollard*, 1898
 Lithograph in black on laid paper, only state
 324 x 279 mm. (image)
 Second edition (1920) of at least 100 impressions
 Printer: Auguste Clot, Paris
 Publisher: Ambroise Vollard, Paris
 Venturi 1158; Cherpin 8; Leymarie/Melot C7; Johnson
 24; Druick II
 Smith College Museum of Art, Northampton,
 Massachusetts
 Gift of Selma Erving (Class of 1927), 1972
 (illus. p. 40)

PIERRE **BONNARD**
French, 1867–1947

13. Portfolio cover for *L'Album d'estampes originales de la
 Galerie Vollard*, 1897
 Lithograph in brown, yellow, green, orange, and beige
 on china paper
 Signed in pencil, lower left: *PBonnard*
 583 x 865 mm. (image)
 Edition of 100
 Printer: Auguste Clot, Paris
 Publisher: Ambroise Vollard, Paris
 Roger-Marx 41; Bouvet 41; Johnson 14
 Smith College Museum of Art, Northampton,
 Massachusetts
 Gift of Selma Irving (Class of 1927), 1984
 (illus. p. 38)

CHARLES-FRANÇOIS **DAUBIGNY**
French, 1817–1878

14. *The "Botin" at Conflans (The Landscapist in the Boat)
 Le "Botin" à Conflans (Le Paysagiste en Bateau)*, 1866
 Etching and drypoint on wove paper, first state
 109 x 143 mm.
 Delteil 119 i/iii; Henriet 109; Melot (1980) D 119
 Mead Art Museum, Amherst College
 Gift of Edward C. Crossett (Class of 1905)
 (illus. p. 17)

JEAN-BAPTISTE-ARMAND **GUILLAUMIN**
French, 1841–1927

15. *The Seine at Charenton (La Seine vue de Charenton)*, 1873
 Illustration to "Itinéraire de Paris par le chemin de fer
 ceinture (dernière étape)" in *Paris à l'eau-forte*, vol. 2,
 no. 23 (31 aout 1873), 55
 Etching on *chine collé*, second state
 52 x 76 mm.
 Printer: Auguste Delâtre, Paris
 Publisher: Richard Lesclide, Paris
 Kraemer 7i ii/ii; Gray 36 (as *Charonton* (sic): *les rameurs*)
 W. E. B. Du Bois Library, University of Massachusetts,
 Amherst
 (illus. p. 24)

16. *Barrault Lane (La ruelle Barrault)*, 1873
 Illustration to "Un Rocambole inédit" in *Paris à l'eau-
 forte*, vol. 2, no. 23 (31 aout 1873), 57
 Etching on *chine collé*, second state
 Signed in the plate, lower right: *Guillaumin*
 Title in the plate, lower left: *La Ruelle Barrault*
 92 x 175 mm.
 Printer: Auguste Delâtre, Paris
 Publisher: Richard Lesclide, Paris
 Kraemer 10A ii/ii; Melot 286
 W. E. B. Du Bois Library, University of Massachusetts,
 Amherst

Cat. 16

17. *The Marshes at Vitry (Le marais de Vitry)*, 1873
 Illustration to "Un Rocambole inédit" in *Paris à l'eau-
 forte*, vol. 2, no. 23 (31 aout 1873), 59
 Etching on *chine collé*, second state
 70 x 107 mm.
 Printer: Auguste Delâtre, Paris
 Publisher: Richard Lesclide, Paris
 Kraemer 7G ii/ii

W. E. B. Du Bois Library, University of Massachusetts, Amherst

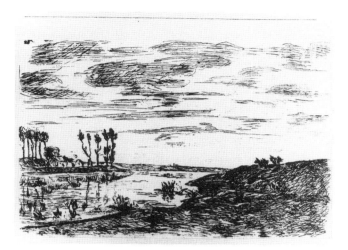

Cat. 17

18. *Chemin des Hautes-Bruyères*, 1873
Illustration to "Un Rocambole inédit" in *Paris à l'eau-forte*, vol. 2, no. 23 (31 aout 1873), 61
Etching on *chine collé*, second state
Title in the plate, lower center: *Chemin des Hautes-Bruyères*
Monogram in the plate, lower left: *AG*
76 x 107 mm.
Printer: Auguste Delâtre, Paris
Publisher: Richard Lesclide, Paris
Kraemer 10D ii/ii; Melot 286
W. E. B. Du Bois Library, University of Massachusetts, Amherst
(illus. p. 37)

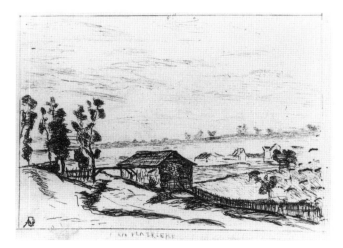

Cat. 19

19. *La Plâtrière* or *L'Ile de Sasseuil (Gironde)*, 1873
Illustration to "Etudes rustiques. Les boeufs," in *Paris à l'eau-forte*, vol. 2, no. 27 (28 septembre 1873), 113
Etching on *chine collé*, second state
Title in the plate, lower center: *La Plâtrière*
Monogram in the plate, lower left: *AG*
75 x 103 mm.
Printer: Auguste Delâtre, Paris

Publisher: Richard Lesclide, Paris
Kraemer 10C ii/ii; Melot 286
W. E. B. Du Bois Library, University of Massachusetts, Amherst

20. *Seascape at Charenton (Une marine à Charenton)*, 1873
Illustration to "Promenade champêtre. Le Moulin," in *Paris à l'eau-forte*, vol. 2, no. 31 (26 octobre 1873), 181
Etching on *chine collé*, second state
47 x 77 mm.
Printer: Auguste Delâtre, Paris
Publisher: Richard Lesclide, Paris
Kraemer 7H ii/ii
W. E. B. Du Bois Library, University of Massachusetts, Amherst
(illus. p. 24)

21. *Bas Meudon* or *In the Tall Grass (Dans les hautes herbes)*, 1873
Illustration to "Promenade fantaisiste," in *Paris à l'eau-forte*, vol. 2, no. 32 (2 novembre 1873), 199
Etching on *chine collé*, second state
Title in the plate, lower center: *Bas Meudon*
Monogram, lower right: *AG*
68 x 90 mm.
Printer: Auguste Delâtre, Paris
Publisher: Richard Lesclide, Paris
Kraemer 7F ii/ii
W. E. B. Du Bois Library, University of Massachusetts, Amherst
(illus. p. 26)

22. *A Long Road (Une longue route)* or *Entrance to the Village (Entrée de village)*, 1873
Illustration to "Au Verger," in *Paris à l'eau-forte*, vol. 2, no. 33 (9 novembre 1873), 221

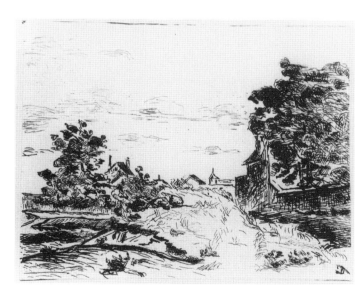

Cat. 22

Etching on *chine collé*, second state
Monogram, lower right: *AG*
68 x 90 mm.
Printer: Auguste Delâtre, Paris
Publisher: Richard Lesclide, Paris
Kraemer 7E ii/ii
W. E. B. Du Bois Library, University of Massachusetts, Amherst

23. *The Bercy Bridge (Pont de Bercy)*, 1873
Etching on wove paper
Emblematic signature in the plate, upper left: cat with
arched back
Title in the plate, lower center: *Le Pont de Bercy*; date in
plate, lower left: *7br 1873*
170 x 267 mm.
Kraemer 15; Melot 284
Philadelphia Museum of Art
Purchased with the John D. McIlhenny Fund
(illus. p. 24)

JOHANN-BARTHOLD **JONGKIND**
Dutch, 1818–1891

24. *Windmills in Holland (Moulins en Hollande)*, 1867
Etching on laid paper, second state
Signed and dated in the plate, lower right: *Rotterdam 1867
Jongkind*
147 x 195 mm.
Publisher: Alfred Cadart
Delteil 14 ii/iii; Hefting 444; Melot (1980) J 14 ii/iii
Mead Art Museum, Amherst College
Gift of Alexander C. Allison, Mary V. Allison and Peter B.
Allison in memory of William K. Allison (Class of 1920)
and Mrs. Allison
(illus. p. 27)

25. *Demolition on the Rue des Francs-Bourgeois Saint-Marcel
(Démolitions de la rue des Francs-Bourgeois Saint-Marcel)*,
1873
Etching on laid paper, second state
Signed in the plate, lower right: *Jongkind 1873*
Handwritten inscription in ink in margin, above left: *1ª
Epreuve Paris 5 avril 1873/ Chez monsieur Delâtre 303 rue
St. Jacques*; lower margin: *Démolition de la rue Francs.
Bourgeois St. Marcel - quartier Mouftard. Paris 17 avril
1868 - actuellement Boulevard du Port Royal -/ Paris 5
avril 1873 Jongkind, 5 rue de Chevreuse*
160 x 243 mm.
Printer: Auguste Delâtre, Paris
Publisher: Alfred Cadart, Paris
Delteil 18 ii/iv; Hefting 665; Melot (1980) J 18 ii/iv
Mead Art Museum, Amherst College
Gift of Edward C. Crossett (Class of 1905)
(illus. p. 27)

26. *Leaving the Maison Cochin, Faubourg Saint-Jacques
(Sortie de la Maison Cochin, Faubourg Saint-Jacques)*, 1878
Etching on laid paper, second state
Signed and dated in the plate, lower right: *Jongkind 1878*;
lower left: *3 nov (?)1878, Paris*
Inscription in ink, lower margin: *Sortie de la maison Cochin
faubourg St. Jacques à Paris/ Imprimerie Cadart boulevard
Haussmann 56, le 12 juin 1879/ Jongkind*
160 x 238 mm.
Publisher: Alfred Cadart, Paris
Delteil 20 ii/iv; Hefting 709; Melot (1980) J 20 ii/iv
Mead Art Museum, Amherst College
Gift of Edward C. Crossett (Class of 1905)

CAMILLE **PISSARRO**
French (born in St. Thomas, Danish West Indies), 1830–1903

27. *Hills at Pontoise (Coteaux à Pontoise)*, 1873
Etching on wove paper
Signed on the plate, lower left: *Pissarro*
Emblematic signature in the plate, lower left, upper right:
daisy
120 x 160 mm.
Delteil 7; Leymarie/Melot P7
S. P. Avery Collection, Miriam and Ira D. Wallach Division
of Art, Prints and Photographs, The New York Public
Library, Astor, Lenox and Tilden Foundation
(illus. p. 52)

28. *The Oise River at Pontoise (L'Oise à Pontoise)*, 1873
Etching on wove paper
Signed in the plate, lower left: *Pissarro*
Emblematic signature in the plate, upper right: daisy
79 x 120 mm.
Delteil 9; Leymarie/Melot P9
S. P. Avery Collection, Miriam and Ira D. Wallach Division
of Art, Prints and Photographs, The New York Public
Library, Astor, Lenox and Tilden Foundation
(illus. p. 25)

29. *Peasant Woman Feeding a Child (Paysanne donnant à
manger à un enfant)*, 1873 (reworked 1889)

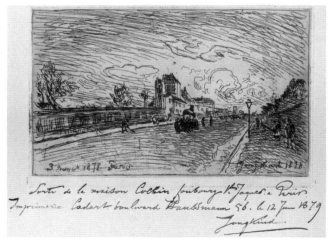

Cat. 26

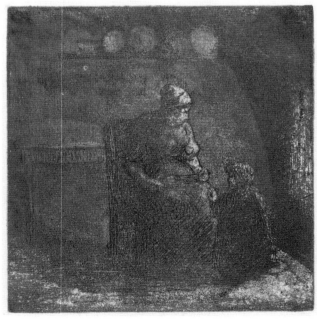

Cat. 29

Etching and aquatint, third state
Emblematic signature in the plate, lower left: daisy
Inscription in pencil: *3è état no. 1 unique/ zinc aqua/imp. par P.C.*
125 x 120 mm.
Only known proof for 1889 reworking of the plate
Delteil 12 iii/iv; Leymarie/Melot P12
Museum of Fine Arts, Boston
Gift of Mr. and Mrs. Adolph Weil Jr. in memory of Adolph and Rossie Schoenhof Weil, 1977
(illus. p. 56)

30. *Paul Cézanne*, 1874
Etching on laid paper
Trial proof
269 x 216 mm.
Printer: Camille Pissarro, Auvers-sur-Oise (?)
Delteil 13; Leymarie/Melot P13
Fogg Art Museum, Harvard University Art Museums
Francis H. Burr Fund
(illus. p. 19)

31. *Portrait of the Artist's Son, Lucien (Portrait de Lucien [Pissarro])*, 1874
Lithograph on wove paper
Signed and dated in the stone, lower right : *C. Pissarro/ 1874*; upper right in graphite pencil: *Portrait de Lucien*
210 x 280 mm.
One of four known impressions
Delteil 128 (the impression illustrated); Leymarie/Melot P132
Museum of Fine Arts, Boston
Stephen Bullard Memorial Fund, 1972
(illus. p. 36)

32. *A Street at Les Pâtis, near Pontoise (Une rue aux Pâtis, Pontoise)*, 1874
Lithograph on wove paper
Signed on the stone, lower left: *C. Pissarro*
265 x 220 mm.
Delteil 130; Leymarie/Melot P134
S. P. Avery Collection, Miriam and Ira D. Wallach Division of Art, Prints and Photographs, The New York Public Library, Astor, Lenox and Tilden Foundation
(illus. p. 48)

Frédéric REGAMEY
French, 1849–1925

33. *Paris à l'eau-forte*, 1873
Emblematic illustration to editorial commentary, "Au Lecteur," in *Paris à l'eau-forte*, vol. 1, no. 1, Numéro-spécimen (mars 1873), 1
Etching on *chine collé*
Signed in the plate, lower left: *Frédéric Regamey*
92 x 101 mm.
Printer: Auguste Delâtre, Paris
Publisher: Richard Lesclide, Paris
Beraldi, p. 180
W. E. B. Du Bois Library, University of Massachusetts, Amherst
(illus. p. 34)

34. *The Free Cat (Le Chat Libre)*, 1873
From "Le Chat Libre," in *Paris à l'eau-forte*, vol. 1, no. 4 (20 avril 1873), 57
Etching on *chine collé*
93 x 84 mm. (image)
Printer: Auguste Delâtre, Paris

Publisher: Richard Lesclide, Paris
Beraldi, p. 180
W. E. B. Du Bois Library, University of Massachusetts, Amherst
(illus. p. 34)

35. *First poster for Paris à l'eau-forte (Première affiche de Paris à l'Eau-Forte)*, 1873
Reduced, etched version of original poster
From "Les Affiches de Paris à l'eau-forte," in *Paris à l'eau-forte*, vol. 1, no., 4 (20 avril 1873), 60
Etching on *chine collé*
Signed in the plate, lower right: *Frédéric Regamey*
88 x 62 mm.
Printer: Auguste Delâtre, Paris
Publisher: Richard Lesclide, Paris
Beraldi, p. 180
W. E. B. Du Bois Library, University of Massachusetts, Amherst
(illus. p. 34)

36. *Double Portrait of Richard Lesclide and Frédéric Regamey*, 1873
Title page of *Paris à l'eau-forte*, vol. 2 (aout 1873 à november 1873)
Etching on *chine collé*
Monogram of the artist in the plate, lower left
56 x 73 mm. (sheet)
Printer: Auguste Delâtre, Paris
Publisher: Richard Lesclide, Paris
Beraldi, p. 180
W. E. B. Du Bois Library, University of Massachusetts, Amherst
(illus. p. 33)

Pierre-Auguste RENOIR
French, 1841–1919

37. *The Pinned Hat (Le Chapeau épinglé)*, 1898
Lithograph in yellow, red, green, orange, gray, pink, blue, brown, and black on Arches laid paper
Signed in stone, lower right: *Renoir*
608 x 495 mm. (image)
Printer: Auguste Clot, Paris
Publisher: Ambroise Vollard, Paris
Delteil 30; Roger-Marx 5 bis, Stella 30
Smith College Museum of Art, Northampton, Massachusetts
Gift of Mrs. John Wintersteen (Bernice McIlhenny, Class of 1925)
(illus. p. 47)

38. *Ambroise Vollard*, 1904
From *Douze Lithographies Originales de Pierre-Auguste Renoir*, 1919
Lithograph
247 x 178 mm. (image)
Printer: Auguste Clot, Paris
Publisher: Ambroise Vollard, Paris
Delteil 38; Roger-Marx 13; Stella 37
Smith College Museum of Art, Northampton, Massachusetts
Gift of Selma Erving (Class of 1927), 1975
(illus. p. 39)

PAUL VAN RYSSEL
(PSEUD. OF DR. PAUL-FERDINAND GACHET)
French, 1828–1909

39. *House in the Rocks (Road from Pontoise to Auvers)*
 (Maison dans les Roches [Route de Pontoise à Auvers]),
 August 1873
 Etching on laid paper
 Emblematic signature in the plate, upper left: duck
 134 x 107 mm.
 Printer: Dr. Paul Gachet, Auvers-sur-Oise
 Gachet 7; Adhémar 7
 Stamped: head of a cat (Dr. Paul Gachet, Lugt 2807c
 suppl.)
 Philadelphia Museum of Art
 Gift of Henry P. McIlhenny
 (illus. p. 30)

40. *Madame Gachet at the Piano (Madame Gachet au Piano)*,
 September 1873
 Etching on laid paper
 Signed in the plate, upper left: *P. V. Ryssel/ ? 1873*
 Emblematic signature in the plate, upper right: duck
 180 x 150 mm.
 Printer: Dr. Paul Gachet, Auvers-sur-Oise
 Gachet 8; Adhémar 8
 Stamped: head of a cat (Dr. Paul Gachet, Lugt 2807c
 suppl.)
 Philadelphia Museum of Art
 Gift of Henry P. McIlhenny

41. *View of Auvers-sur-Oise (Vue d'Auvers-sur-Oise)*, November
 1873
 Etching on laid paper
 Signed in the plate, lower left: *P. V. R.*
 Emblematic signature in the plate, upper left: duck
 119 x 156 mm.
 Printer: Dr. Paul Gachet, Auvers-sur-Oise
 Gachet 12; Adhémar 13
 Stamped: head of a cat (Dr. Paul Gachet, Lugt 2807c
 suppl.)
 Philadelphia Museum of Art
 Gift of Henry P. McIlhenny
 (illus. p. 29)

42. *Notre Dame de Paris*, 1873
 From "Une soirée chez Victor Hugo," in *Paris à l'eau
 forte*, vol. 3, no. 40 (28 decembre 1873), 65
 Etching on *chine collé*
 72 x 112 mm.
 Printer: Auguste Delâtre, Paris
 Publisher: Richard Lesclide, Paris
 W. E. B. Du Bois Library, University of Massachusetts,
 Amherst
 (illus. p. 35)

43. *Riverbank at Guernsey (Rivage de Guernesey)*, 1873
 Illustration to "Une soirée chez Victor Hugo," in *Paris à
 l'eau-forte*, vol. 3, no. 40 (28 decembre 1873), 67
 Etching on *chine collé*
 37 x 100 mm.
 Printer: Auguste Delâtre, Paris
 Publisher: Richard Lesclide, Paris
 W. E. B. Du Bois Library, University of Massachusetts,
 Amherst
 (illus. p. 35)

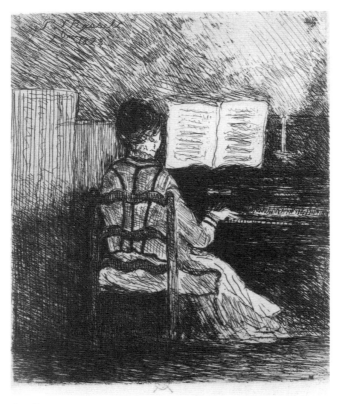

Cat. 40

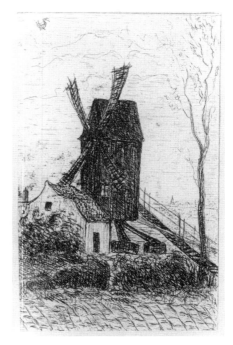

Cat. 44

44. *The Windmill (Le Moulin)*, 1874
 Illustration to "La France de Watteau," in *Paris à l'eau-
 forte*, vol. 3, no. 42 (11 janvier 1874), 101
 Etching on *chine collé*

81 x 49 mm.
Printer: Auguste Delâtre, Paris
Publisher: Richard Lesclide, Paris
W. E. B. Du Bois Library, University of Massachusetts,
Amherst

45. *Murer's Walnut Tree. The Old Road to Auvers*
 (*Le Noyer de Murer. Vieille Route d'Auvers*) or *Automnale*,
 1874
 With poem "Automnale" in *Paris à l'eau-forte*, vol. 5, no.
 81 (25 octobre 1874), opp. 199
 Etching on laid paper
 Signed in plate, upper right: *P. V. R.*
 Emblematic signature in the plate, upper left: duck
 95 x 131 mm.
 Printer: Auguste Delâtre, Paris
 Publisher: Richard Lesclide, Paris
 Gachet 15; Adhémar 16
 W. E. B. Du Bois Library, University of Massachusetts,
 Amherst
 (illus. p. 29)

46. *View of Auvers-sur-Oise at "Le Chou"*
 (*Vue d'Auvers-sur-Oise "Le Chou"*), 1874
 Etching on laid paper
 Signed and dated in plate, lower left: *1874 P. Van Ryssel*
 Monogram in plate, upper right : *PVR*
 112 x 149 mm.
 Printer: Dr. Paul Gachet, Auvers-sur-Oise
 Gachet 25; Adhémar 26
 Stamped: head of a cat (Dr. Paul Gachet, Lugt 2807c
 suppl.);
 Stamped: P. F. Gachet (Lugt 1195b suppl.) Philadelphia
 Museum of Art
 Gift of Henry P. McIlhenny
 (illus. p. 30)

Vincent **VAN GOGH**
Dutch, 1853–1890

47. *Man with a Pipe (Portrait of Doctor Gachet)*
 (*L'Homme à la pipe [Portrait du Docteur Gachet]*), 1890
 Etching on laid paper
 Inscriptions on recto in pencil: *L'homme à la Pipe (Dr.
 Gachet)/ Auvers 25 mai 1890 Eau forte de Vt Van Gogh/ P.
 Gachet*
 182 x 152 mm.
 La Faille 1664; Hulsker 2028; van Heugten/Pabst 10
 Collection : Dr. Paul Gachet
 Fogg Art Museum, Harvard University Art Museums
 William M. Prichard Fund
 (illus. p. 16)

Bibliography

ADHEMAR
Adhémar, Jean. *Inventaire du fonds français après 1800, Cabinet des Estampes, Bibliothèque nationale*, Paris, t. 4., 1949 (Cézanne), t. 8, 1954 (Gachet).

Adler, Kathleen. *Camille Pissarro, A Biography*, New York, 1977.

Andersen, Wayne. *Cézanne's Portrait Drawings*, Cambridge, Mass. and London, 1970.

Armand Guillaumin, retrospective: l'impressionniste, ami de Cézanne et Van Gogh, 1841–1927, exh. cat. Petit Palais, Paris, 1991.

Bailly-Herzberg, Janine. *Dictionnaire de l'estampe en France 1830–1950*, Paris, 1985. *L'eau-forte de peintre au dix-neuvième siècle. La Société des aquafortistes (1862–1867)*, 2 vols., Paris, 1972.

———. "French Etching in the 1860s," *Art Journal*, vol. 31, no. 4, summer 1972, pp. 382–386.

——— and Madeline Fidell-Beaufort. *Daubigny*, Paris, 1975.

Ballas, Guila. "Daumier, Corot, Papety, et Delacroix, inspirateurs de Cézanne," *Bulletin de la Société de l'histoire de l'art français*, Paris, année 1974 (1975), pp. 193–199.

Baudelaire, Charles. "Painters and Etchers," in Jonathan Mayne, ed., *Art in Paris 1845–1862: Salons and Other Exhibitions Reviewed by Charles Baudelaire*, London, 1965, pp. 217–222.

BARTSCH
Bartsch, Adam. "Adriaen van Ostade," in Le *Peintre-Graveur*, vol. 1, Vienna, 1803, pp. iv–xi, 347–388.

Bazin, Germain, ed. "Van Gogh et les peintres d'Auvers chez le docteur Gachet," *L'Amour de l'art*, Paris, 1952.

Bénézit, E. *Dictionnaire critique et documentaire des peintres, sculpteurs, dessinateurs et graveurs*, vol. 7, Paris, 1962.

Benjamin, Roger. "Recovering Authors: The Modern Copy, Copy Exhibitions, and Matisse," *Art History*, vol. 12, no. 2, June 1989, pp. 176–201.

BERALDI
Beraldi, Henri. *Les Graveurs du XIXe siècle*, 12 vols., Paris, 1885–92, vol. 5, 1886, Daubigny, pp. 91–98; vol. 8, 1889, Jongkind, pp. 278–279; vol. 11, 1981, Regamey, pp. 180–181.

Bernard, Emile. "*Paul Cézanne*," *Les Hommes d'aujourd'hui*, vol. 8, no. 387, 1891.

———. *Souvenirs sur Paul Cézanne et Lettres*, Paris, 1921.

Bernheim-Jeune, Gaston, et al. *Cézanne*, Paris, 1914.

Berthold, Gertrude. *Cézanne und die alten Meister: Die Bedeutung der Zeichnungen Cézannes nach Werken anderer Künstler*, Stuttgart, 1958.

Borély, Jules. "Cézanne à Aix," *L'Art vivant*, no. 2, 1926, pp. 491–493; reprinted in P.M. Doran, *Conversations avec Cézanne*, Paris, 1978, pp. 18–22.

BOUVET
Bouvet, Francis. *Bonnard: The Complete Graphic Work*, trans. Jane Brenton, New York and London, 1981.

Brettell, Richard. "Cézanne/Pissarro: élève/élève" in *Cézanne aujourd'hui, Actes du colloque organisé par le Musée d'Orsay, 29 et 30 novembre 1995*, eds., Françoise Cachin, Henri Loyrette, Stéphane Grégan, Paris, 1997, pp. 29–37.

———. *Pissarro and Pontoise: The Painter in a Landscape*, New Haven and London, 1990.

———. "Pissarro, Cézanne, and the School of Pontoise," in Richard Brettell et al., *A Day in the Country: Impressionism and the French Landscape*, New York, 1990 (1984), pp. 175–205.

Cachin, Françoise, et. al. *Cézanne*, exh. cat., Galeries Nationales du Grand Palais, Paris; Tate Gallery, London; Philadelphia Museum of Art, Philadelphia, 1996.

Cachin, Françoise, Henri Loyrette, and Stéphane Guégan, eds. *Cézanne aujourd'hui, Actes du colloque organisé par le musée d'Orsay, 29 et 30 novembre 1995*, Paris, 1997.

Cahn, Isabelle. "L'Exposition Cézanne chez Vollard en 1895," in *Cézanne aujourd'hui, Actes du colloque organisé par le musée d'Orsay*, Paris, 1997, pp. 135–144.

Cailac, Jean. "The Prints of Camille Pissarro: A Supplement to the Catalogue by Loys Delteil," *The Print Collector's Quarterly*, vol. 19, 1932, pp. 75–86.

Carey, Frances and Antony Griffiths. *From Manet to Toulouse-Lautrec, French Lithographs 1860–1900*, London, 1978.

Cate, Phillip Dennis and Sinclair Hamilton Hitchings. *The Color Revolution, Color Lithography in France 1890–1900*, exh. cat., Rutgers University Art Gallery, 1978.

Cézanne, l'oeuvre gravé. exh. cat., intro. Michel Melot, Pavillon de Vendome, Aix-en-Provence, 1972.

Cézanne, Paul. *Letters*, rev. and aug. ed., John Rewald, ed., trans. Seymour Hacker, New York, 1984.

CHAPPUIS
Chappuis, Adrien. *The Drawings of Paul Cézanne, A Catalogue Raisonné*, 2 vols., Greenwich, Ct., 1973.

CHERPIN
Cherpin, Jean. "L'Oeuvre gravé de Cézanne," *Arts et Livres de Provence*, Bulletin no. 82, Marseilles, 1972.

Chetham, Charles et al. *The Selma Erving Collection: Nineteenth and Twentieth Century Prints*, Smith College Museum of Art, Northampton, Mass., 1985.

Collection du Docteur Gachet. Estampes et dessins du XVe siècle aux impressionnistes, important ensemble de dessins de Louis van Ryssel, Hôtel Drouot, Paris, Sale, 15 May 1993.

Collection Halasz, Important ensemble d'Estampes Originales françaises. . ., Hôtel Drouot, Paris, Sale, 6–7 May 1957.

Cooper, Douglas. "The Painters of Auvers-sur-Oise," *The Burlington Magazine*, vol. 117, no. 624, March 1955, pp. 100–106.

Coutagne, Denis. *Cézanne au musée d'Aix*, exh. cat., Musée Granet, Aix-en-Provence, 1984.

DELTEIL
Delteil, Loys. *Le Peintre-graveur illustré*, 31 vols., Paris, 1906–30: vol. 1, 1906, *Millet, Rousseau, Jongkind, Dupré*; vol. 3, 1908, *Ingres & Delacroix*; vol. 13, 1921, *Charles-François Daubigny*; vol. 17, 1923, *Camille Pissarro, Alfred Sisley, Auguste Renoir*.

Distel, Anne. *Impressionism: The First Collectors*, trans. Barbara Perroud-Benson, New York, 1990.

Doiteau, Victor. "La Curieuse Figure du Dr. Gachet: Un ami et un amateur de la première heure de Cézanne, Renoir, Pissarro, Van Gogh," *Aesculape*, August 1923, pp. 169–173; September 1923, pp. 211–216; November 1923, pp. 250–54; December 1923, pp. 278–283; January 1924, pp. 7–11.

Doran, P. M., ed. *Conversations avec Cézanne*, Paris, 1978.

Dorival, Bernard. *Cézanne*, trans. H.H.A. Thackthwaite, Boston, 1949.

Douglas, Alfred. *The Tarot: The Origins, Meaning and Uses of the Cards*, London, 1972.

DRUICK
Druick, Douglas. "Cézanne's Lithographs," in *Cézanne, The Late Work*, William Rubin, ed., exh. cat., Museum of Modern Art, New York, 1977, pp. 119–137.

———. "Cézanne, Vollard, and Lithography: The Ottawa Maquette for the *Large Bathers* Colour Lithograph," *National Gallery of Canada Bulletin*, no. 19, 1972, pp. 2–34.

——— and Peter Zegers. "Degas and the Printed Image, 1856–1914," in Sue Welsh Reed and Barbara Shapiro, *Edgar Degas: The Painter as Printmaker*, exh. cat., Museum of Fine Arts, Boston, 1984, pp. xv–lxxii.

Duvivier, Christophe. *Armand Guillaumin 1841-1927, les années impressionnistes*, exh. cat., Musée Pissarro, Pontoise, 1991.

Esposito, Carla. "Notes sur la collection d'un excentrique: les estampes du Dr Gachet," *Nouvelles de l'estampe*, no. 126, November–December 1992, pp. 4–8.

Fidell-Beaufort, Madeleine and Janine Bailly-Herzberg. *Daubigny*, Paris, 1975.

Fontainas, André. "Memento," *Mercure de France*, no. 25, January 1989, p. 306.

Gachet, Paul. *Cézanne à Auvers, Cézanne graveur*, Paris, 1952.

———. *Deux amis des impressionnistes, le docteur Gachet et Murer*, Paris, 1956.

GACHET
Gachet, Paul. *Paul van Ryssel: le Docteur Gachet, graveur*, Paris, 1954.

———. *Souvenirs de Cézanne et de van Gogh à Auvers*, Paris, 1953.

———, ed. *Lettres impressionnistes au Dr. Gachet et à Murer*, Paris, 1957.

Gilmour, Pat. "Cher Monsieur Clot . . . Auguste Clot and His Role as a Color Lithographer," in Pat Gilmour, ed. *Lasting Impressions, Lithography as Art*, Philadelphia, 1988, pp. 129–175.

Gogh, Vincent van. *The Complete Letters of Vincent van Gogh*, 2nd ed., with preface and memoir by Johanna van Gogh-Bonger, 3 vols., Greenwich, Ct., 1958.

Goriany, Jean. "Notes on Prints: Cézanne's Lithograph *The Small Bathers*," *Gazette des Beaux-Arts*, vol. 23, February 1943, pp. 123–124.

Gowing, Lawrence. *Paul Cézanne: The Basel Sketchbooks*, exh. cat., Museum of Modern Art, New York, 1988.

——— et al. *Cézanne, The Early Years 1859–1872*, exh. cat., Royal Academy of Arts, London; Musée d'Orsay, Paris; National Gallery of Art, Washington; London, 1988.

GRAY
Gray, Christopher. *Armand Guillaumin*, Chester, Ct., 1972.

HEFTING
Hefting, Victorine. *Jongkind, sa vie, son oeuvre, son époque*, Paris, 1975.

HENRIET
Henriet, Frédéric. "Les Paysagistes contemporains: Daubigny," *Gazette des Beaux-Arts*, vol. 9, 1 May 1874, pp. 464–475.

Herbert, Robert L. *Peasants and "Primitivism," French Prints from Millet to Gauguin*, exh. cat., Mount Holyoke College Art Museum, South Hadley, 1995.

HEUGTEN/PABST
Heugten, Sjaar van and Fieke Pabst. *The Graphic Work of Vincent van Gogh. Cahier Vincent*, no. 6, Zwolle, 1993.

HULSKER
Hulsker, Jan. *The New Complete Van Gogh: Paintings, Drawings, Sketches*, Amsterdam, 1996

Ives, Colta, Helen Giambruni and Sasha M. Newman. *Pierre Bonnard: The Graphic Art*, exh. cat., Metropolitan Museum of Art, New York, 1989.

JOHNSON
Johnson, Una E. *Ambroise Vollard, Editeur: Prints, Books, Bronzes*, New York, 1977.

KRAEMER
Kraemer, Gilles. *Armand Guillaumin 1841–1927, Gravures et Lithographies*, exh. cat., Musée des Beaux-Arts, Clermont-Ferrand, 1995.

Krumrine, Mary Louise with Gottfried Boehm and Christian Geelhaar. *Paul Cézanne: The Bathers*, New York, 1990.

LA FAILLE
la Faille, J.-B de. *The Works of Vincent van Gogh*, New York, 1970.

Lesclide, Richard, ed. *Paris à l'eau forte, Actualité. Curiosité. Fantasie*, 5 vols., Paris, 1873–76.

LEYMARIE/MELOT
Leymarie, Jean and Michel Melot. *The Graphic Works of the Impressionists: Manet, Pissarro, Renoir, Cézanne, Sisley*, trans. Jane Brenton, New York, 1972.

Lichtenstein, Sara. "Cézanne and Delacroix," *The Art Bulletin*, vol. 46, no. 1, March 1964, pp. 55–67.

Lloyd, Christopher. *Camille Pissarro*, Geneva, 1981.

———. "Paul Cézanne, 'Pupil of Pissarro,' An Artistic Friendship," *Apollo*, vol. 136, November 1992, pp. 284–290.

Lugt, Frits. *Les Marques de collections de dessins & d'estampes . . . Supplément*, La Haye, 1956.

McQueen, Alison. *The Modern Artist and the Old Master: The Reinvention of Rembrandt in France 1850–1900*, Ph.D. diss., University of Pittsburgh, 1998.

Mellerio, André. "Exposition de la deuxième année de 'L'Album d'Estampes Originales:' Galerie Vollard, 6 rue Lafitte." *L'Estampe et l'Affiche*, 1998, pp. 10–12.

———. *La Lithographie Originale en couleurs*, Paris, 1898, trans. Margaret Needham, reprinted in Phillip Dennis Cate and Sinclair Hitchings, *The Color Revolution, Color Lithography in France 1890–1900*, exh. cat., Rutgers University Art Gallery, 1978, pp. 77–99.

MELOT
Melot, Michel. *L'Estampe impressionniste*, exh. cat., Bibliothèque nationale, Paris, 1974.

MELOT (1980)
Melot, Michel. *Graphic Art of the Pre-Impressionists*, New York, 1980.

———. *The Impressionist Print*, trans. Caroline Beamish, New Haven and London, 1996 (1994).

Monneret, Sophie. *L'impressionisme et son époque. Dictionnaire international*, 2 vols., Paris, 1978.

Montfort, Juliana. "Van Gogh et la gravure," *Nouvelles de l'estampe*, no. 2, March–April 1972, pp. 5–13.

Murphy, Richard. *The World of Cézanne, 1839–1906*, New York, 1968.

Norman, Geraldine. "Fakes?" *The New York Review of Books*, February 5, 1998, pp. 4–7.

Novotny, Fritz. "Zu einer 'Kopie' von Cézanne nach Ostade," *Pantheon*, vol. 25, no. 4, July–August 1967, pp. 276–280.

Passeron, Roger. *Impressionist Prints*, New York, 1974.

Perruchot, Henri. *Cézanne*, trans. Humphrey Hore, New York, 1963.

Phagan, Patricia, ed. *Adriaen van Ostade: Etchings of Peasant Life in Holland's Golden Age*, exh. cat., Georgia Museum of Art, University of Georgia, Athens, 1994.

Pickvance, Ronald. *Van Gogh in Saint-Rémy and Auvers*, exh. cat., Metropolitan Museum of Art, New York, 1986.

Pissarro. exh. cat., Hayward Gallery, London; Grand Palais, Paris; Museum of Fine Arts, Boston, 1980.

Pissarro, Camille. *Correspondance de Camille Pissarro*, ed. Janine Billy-Herzberg, 5 vols., Paris, 1980–91.

———. *Letters to His Son Lucien*, ed. John Rewald, New York, 1995.

Pissarro, Joachim. *Camille Pissarro*, New York, 1993.

Pissarro, Ludovico-Rodo and Lionello Venturi. *Camille Pissarro: son art—son oeuvre*, 2 vols., Paris, 1939.

Reed, Sue Welsh and Barbara Stern Shapiro. *Edgar Degas: The Painter as Printmaker*, exh. cat., Museum of Fine Arts, Boston, 1984.

Reff, Theodore. "Cézanne: The Severed Head and the Skull," *Arts Magazine*, vol. 58, no. 2, 2 October 1983, pp. 85–100.

———. "Cézanne's Constructive Stroke," *The Art Quarterly*, vol. 25, no. 3, autumn 1962, pp. 214–226.

———. "Cézanne's Drawings," *The Burlington Magazine*, vol. 117, July 1975, pp. 489–491.

———. "Pissarro's Portrait of Cézanne," *The Burlington Magazine*, vol. 109, 1967, pp. 627–633.

———. "Reproductions and Books in Cézanne's Studio," *Gazette des Beaux-Arts*, vol. 56, November 1960, pp. 303–309.

Rewald, John. *Cézanne, A Biography*, New York, 1986.

———. "Cézanne and Guillaumin," in *Studies in Impressionism*, eds. Irene Gordon and Frances Weitzenhoffer, New York, 1985, pp. 103–119.

———. "Gachet's Unknown Gems Emerge," *Art News*, vol. 51, March 1952, pp. 7, 18, 63–66.

———. *The History of Impressionism*, New York, 1961.

———. *Paul Cézanne: A Biography*, New York, 1948.

REWALD
——— in collaboration with Walter Feilchenfeldt and Jayne Warman. *The Paintings of Paul Cézanne, A Catalogue Raisonné*, 2 vols., New York, 1996.

Rishel, Joseph J. *Cézanne in Philadephia Collections*, exh. cat., Philadelphia Museum of Art, 1983.

Rodo, Ludovico. "The Etched and Lithographed Work of Camille Pissarro," *The Print Collector's Quarterly*, vol. 9, October 1922, pp. 274–301.

ROGER-MARX
Roger-Marx, Claude. *Bonnard lithographie*, Monte Carlo, 1952.

———. *Les lithographies de Renoir*, Monte Carlo, 1951.

Rousseau, Claudia. "Cézanne, Dr. Gachet and the Hanged Man," *Source: Notes in the History of Art*, vol. 6, no. 1, fall 1986, pp. 29–35.

Rubin, William, ed. *Cézanne, The Late Work*, exh. cat., Museum of Modern Art, New York, 1977.

SALAMON
Salamon, Harry. "Paul Cézanne: Critical Notes and Catalogue of His Engravings," *Print Collector*, no 4, September–October 1973, pp. 30–45.

Saltzman, Cynthia. *Portrait of Dr. Gachet, The Story of a van Gogh Masterpiece: Modernism, Money, Politics, Collectors, Dealers, Taste, Greed, and Loss*, New York, 1988.

Serret, G. and D. Fabiani. *Armand Guillaumin 1841–1927: Catalogue raisonné de l'oeuvre peintre*, Paris, 1971.

Shapiro, Barbara Stern *Camille Pissarro, The Impressionist Print*, Boston, 1973.

———. "Pissarro as print-maker," in *Pissarro*, exh. cat., Hayward Gallery, London; Grand Palais, Paris; Museum of Fine Arts, Boston, 1980, pp. 191–234.

Shiff, Richard. *Cézanne and the End of Impressionism*, Chicago and London, 1984.

Shikes, Ralph and Paula Harper. *Pissarro, His Life and Work*, New York, 1980.

Simon, Robert. "Cézanne and the Subject of Violence," *Art in America*, vol. 79., no. 5, May 1991, pp. 120–135, 185, 186.

STELLA
Stella, Joseph G. *The Graphic Work of Renoir*, New York, 1975.

Thomson, Richard. *Camille Pissarro: Impressionism, Landscape and Rural Labour*, New Amsterdam and New York, 1990.

Trenard, L. "Gachet," *Dictionnaire de Biographie française*, vol. 14, 1976, pp. 1526–1527.

Vandenbroucke, U. F. and J. Sonolet, *Qui était le Docteur Gachet?*, Auvers-sur-Oise, 1980.

Van Gogh et le Peintres d'Auvers-sur-Oise, preface Germain Bazin, exh. cat., Orangerie des Tuileries, Paris, 1954.

VENTURI
Venturi, Lionello. *Cézanne, son art—son oeuvre*, 2 vols., Paris, 1936

———. "*Hamlet and Horatio*: A Painting by Paul Cézanne," *Art Quarterly*, vol. 19, no. 3, autumn 1956, pp. 270–271.

Vollard, Ambroise. *Paul Cézanne*, Paris, 1914.

———. *Recollections of a Picture Dealer*, trans. Violet MacDonald, Boston, 1936.

———. "Souvenirs sur Cézanne," *Cahiers d'Art*, vol. 6, nos. 9-10, 1931, pp. 386–395.

Waldfogel, Melvin. "Caillebotte, Vollard and Cézanne," *Gazette des Beaux-Arts*, vol. 65, 1965, pp.113–120.

White, Barbara Ehrlich. *Impressionists Side by Side. Their Friendships, Rivalries, and Artistic Exchanges*, New York, 1996.

Wickendon, Robert. "Charles-François Daubigny. Painter and Etcher," *The Print Collector's Quarterly*, April 1913, pp. 177–206.

Zemel, Carol. *Van Gogh's Progress: Utopia, Modernity, and Late-Nineteenth-Century Art*, Berkeley, Los Angeles, and London, 1997.

Zerbe, Kathryn J. "The Phoenix Rises from Eros, not Ashes: Creative Collaboration in the Lives of Five Impressionist and Postimpressionist Women Artists," *Journal of the American Academy of Psychoanalysis*, vol. 20, no. 2, 1992, pp. 295–315.

Zola, Emile. "Jonkind," *La Cloche*, 23 January 1872, reprinted in Victorine Hefting, *Jongkind, sa vie, son oeuvre, son époque*, Paris, 1975, p. 369.